Letter-forms
& Lettering

A B

Letter-forms
& Lettering

Towards

an

understanding

of the

shapes of

letters

JOHN R. BIGGS

Blandford Press | 1977

Dedicated to
all lovers of lettering
wherever they
may be,
especially Nellie

Ex Libris, wood engraving
by L. S. Hizhinsky

ACKNOWLEDGEMENTS are due to the various museums and libraries for permission to take and use photographs, notably the British Museum, the British Library, the Leningrad Public Library, the Lenin Library, Moscow, and to the numerous people who have helped either with loan of work or in discussion. Among these are Andre Gurtler, Armin Hofmann, Alvin Eisenman, Ascher Oron, Kei Mori, Kathuichi Ito, Yasaburo Kuwayama, Katsumi Nagata, Takao Hayashi, Masahiko Kozuka, Ken Davies. The section on Cyrillic could not have been written without the willing and patient help of Nellie Lvova, Vadim Lazursky, Vera Lukyanenko, E. Granstrom, N. Rozov, N. Vizir, Villu Toots and many others. I am grateful to Charles Potts and Dennis Rickett of Kingston Polytechnic for the photographs of Pine's Horace.

Contents

Alphabet by Villu Toots

Preliminary Statement 7

Latin Script

 The Historical Approach 31
 The Legibility Approach 43
 A Method of Practice 48

The Roman Alphabet
 An Analysis of the Norm 63
 A Few Model Variants 72

Non-Latin Scripts 97
 Cyrillic (mainly Russian) 101
 Hebrew 111
 Arabic 115
 Chinese and Japanese 119

Book List 128

Alphabet freely drawn with a brush by Karlgeorg Hoefer

Letter-forms & Lettering

A consideration of the study
of letters as
THINGS
as well as symbols of things
or of sounds of speech

Preliminary Statement

Letters are things. They have length and breadth and some-times depth. They make language visible. The shapes of black and white which you are reading are governed by the same principles of proportion and visual design and respect for materials and function as the design of anything in which appearance is an important factor. Here, lettering is thought of as letters in any medium, but for practical reasons, mainly written and printed forms are examined.

The particular series of shapes before your eyes comprise an alphabet. An alphabet is a series of symbols representing the sounds of speech and hence signify ideas. But ideas can be recorded, and thereby communicated across time and space, by shapes or symbols which are not part of an alpha-bet, as in Chinese and Japanese.

It is one of the aims of this book not only to look at the composition of our own Latin letters as being composed largely of straight lines and a few curves, but to compare them with other major alphabets like Cyrillic, and Arabic and Hebrew, and with the non-alphabetic or ideographic systems like Chinese and Japanese. This is not only interesting intellectually and stimulating aesthetically, but it may also have practical value in these days when there is need to communicate at many levels with people all over the world. On a commercial level, there is need to produce publicity material in many languages in order to sell goods and give instructions as to the use of equipment. On the level of ideas there is a greater need than ever for the cultures of one half of the world to understand the culture of the other half. In practice, this means the communication of ideas mainly in printed language.

My own first experience of oriental letter-forms was many years ago, working in an advertising agency where I found myself working on advertisements in Chinese, for a brand of aspirin and intended for newspapers in the West Indies and the Malay Peninsular. Today the need is pressing to study both Cyrillic and Arabic, for obvious reasons. But as will be seen on page 30, both these alphabets have the same distant ancestor as our own Latin alphabet.

The reader may at first be a little bewildered by the un-accustomed shapes, rhythms and textures. It is necessary to cultivate a detached view and overcome the feeling of strangeness, almost of fear, at the sight of an unfamiliar script. But when we remember that the principal of the relationship between strokes and the resulting shapes which they enclose, is the same whether the forms are alphabetic or ideographic, it becomes a design problem like any other.

Up to a point, not knowing the meaning of the letters may be considered an advantage. One is able to concentrate on the nature and clarity of the shapes without being distracted by the associations of meaning. Many of the best teachers of lettering recommend practising with the relationship and rhythm of abstract shapes free from semantic associations before dealing with letters in words with their inevitable intellectual and emotional connotations. Naturally, in due course, the effectiveness of a letter-form must be tested by those who read it. In order to see our own letter-forms with the detachment which is necessary if we wish to create new forms, we must try to get rid of pre-conceptions, and see letters in their simplest basic shapes.

As there are so many books on the history of writing and lettering, it is not proposed to deal with history in depth or detail. Nevertheless, an alphabet cannot properly be under-stood without a knowledge of its history and development.

Our alphabet is given. It is there. It is here. It is handed down to us from the past—and none the worse for that.

The past is prelude.

To appreciate and use intelligently our letter-forms, we must understand how they became what they are. It is impractical to invent a completely new alphabet, though we may invent new variants. The range of variants, while still remaining intelligible in a given context, is enormous.

At this point let us consider letter-forms and the computer. For letters to be recognised by a computer every letter must be so distinct that one letter cannot be confused with another in electronic terms. This has led to the kind of letters and figures that appear on cheques which can be 'read' by machine. Though I doubt if anybody would call them good looking, nevertheless they are being imitated in types that are intended to be read by human beings only, as though by using a type which resembles these electronic letters it will imply that the user is up-to-date and 'with it'.

Yet the need for a letter-form that can be recognised by a machine and also by the human eye without being visually offensive is still here. This is not to say that some of the designs already produced do not go a long way towards that objective—but so far I am unaware of a letter-form which really satisfies an eye trained in the classical tradition and at the same time meets the requirements of the machine.

This is related to the problem of letter-forms for projection on cathode ray tubes (CRT) or television which must survive the distorting influence of the scanning process.

To design a good letter for such media requires a trained eye and a mind ready to deal with technicalities.

Today, we are in a sense living through some of the early stages in the history of writing. Most forms of writing began as simplified pictures of things (pictograms). Modern pictograms are being devised and used for indicating toilets, cafes and the like; ideograms are being created for the motorways and for safety instructions on equipment. Indeed, wherever there is an urgent need to communicate in the absence of a common language of script, pictograms perform a very vital function. It seems to me that the pressure of necessity to communicate resulting in a pictogram is very close to the conditions of the invention of writing thousands of years ago.

Completely new alphabets have been considered for a few of the 1500 languages spoken in Africa and there are many languages in other parts of the world which have no written form. The most obvious solution to the problem is to use an existing alphabet or form of writing. But think of the political and religious obstacles that arise if one of the existing alphabets was used to transliterate such languages. Arabic is likely to bring with it the religion and culture of Islam. The Latin alphabet is accompanied not only by the culture of Greece and Rome but by Christianity and European and American ways of life. The use of Cyrillic could involve the Soviet ideas of communism and its associated philosophy. These philosophies or religions may not necessarily be appropriate for the developing countries.

However, a completely new alphabet seems unlikely for a variety of practical reasons. Nevertheless, the student would learn a lot about the nature and function of an alphabet if he tried to design one from scratch, if he tried to devise a clearly perceptible shape for each sound of the language and then relate them into a harmonious visually satisfying series. Having made that effort he should return to his own 'given' alphabet with a chastened eye and mind.

Among the many notions I hope the reader will appreciate in this book is that lettering is fun, whether as a craft to be practised or a subject to be studied. The study of lettering is close to the study of language and encourages a logical attitude of mind. Making letters develops manual dexterity and coordination of hand and eye; it trains observation. Drawing letters is as much a discipline in drawing as the drawing of other things. The study of the evolution of lettering or writing naturally involves history, indeed writing is at the heart of history. The history of letters outlines the history of civilisation itself.

Today, the invention of transfer letters has eliminated the humbler forms of lettering and made redundant what I must reluctantly call the hack letterer of the thirties and forties. The training of 'commercial' letterers provided a pool of skill from which the rarer creative letterer could arise. Many people feared that transfer lettering had killed 'hand' lettering. This has not proved to be so. But the emphasis has changed.

We read far more printed letters than letters in any other medium and printing types have provided the norm for our perception and appreciation of letters. It is in type design that most (but by no means all) of the really creative energy in letter-forms is still to be found. Until comparatively recently, to produce a new type design was a long and expensive business. New technology has made it possible for new type faces to be produced which would have been out of the question in the past. As Professor Alvin Eisenman of Yale University said 'whereas not so long ago each country could support only one or two type-designers, they will shortly need a hundred'. I suppose there has never been a period when so many type-faces and alphabets have been produced in so short a period as in the last ten or fifteen years.

Lettering may be produced for very different reasons for very different environments. Though the underlying shapes of any alphabet may be the same—the treatment of the letters may be so different as to appear to be inspired by a different aesthetic. A type intended to be read continuously in small sizes must have instant legibility at the top of the priorities. Eccentricities and frivolities would be out of place. But there are times when frivolity, gaiety, light-heartedness, playfulness, fantasy, even wantonness, may have a place. Letters need not always be in their working clothes, or dressed in the formality appropriate to a funeral. They may be simple and plain or decorated and adorned according to the occasion. Types for continuous reading must be judged with a cool, utilitarian even ruthless logic, but letters for ceremonial occasions may need to be judged as works of art in which personal expression of the artist or interpretation of a literary theme may be paramount factors.

Letters are both working tools and objects of joy and contemplation. As tools they may be measured and tested by physiology, psychology and optics; as objects d'art they are no more measurable than any other works of art.

Book plate
Wood engraving by
John R. Biggs

Opposite:
Brush letters
written with
bravura by
Villu Toots

Of the twenty-six letters of our Latin alphabet no less than fifteen A, E, F, H, I, K, L, M, N, T, V, W, X, Y, Z are composed of straight lines only. Six of these are made up entirely of vertical and horizontal lines E, F, H, I, L, T and nine letters have diagonals as well as horizontals and verticals A, K, M, N, V, W, X, Y, Z. Five letters are circular or are closely related to a

circle C, G, O, Q, S; and six have parts of circles together
with straight lines B, D, J, P, R, U. A total of twenty-one letters
out of the twenty-six, with straight lines.

We have said that there are six letters made up entirely of vertical and horizontal lines. The relationship of vertical lines to one another and the relationship of horizontal lines to one another, and the relationship of plain horizontal lines with plain vertical lines is at the heart of visual design. Architecture is largely composed of horizontal and vertical lines. A striped pattern is one of the most fundamental and satisfying of fabric designs, and the combination of horizontal and vertical lines crossing one another results in the plaid. A beautiful

style of Arabic writing known as Kufic is composed entirely of horizontal and vertical lines. See pages 114 and 116. Also compare with Russian Vyaz, page 100.

The importance of parallel lines, whether vertical, horizontal or diagonal is evident in heraldry. The simplest, and oldest of devices is a simple stripe, or stripes upon the shield. In heraldic language the whole background of the shield is known as the field.

Heraldry is a kind of 'corporate image' or 'house style'.

12

That is to say, originally the shields, and the coats worn over armour by knights, had a device on them that could readily be recognised. In the confusion of battle it was necessary to have some distinguishing family sign on shields and coats (hence, coats of arms—that is coats on which armorial bearings were embroidered or woven). These had to be simple to be recognised in the turmoil of the fight. One of the simplest was a vertical stripe down the middle of the shield (pale), or two or three vertical stripes (paly). Another family might have a horizontal band (bar) or two or more horizontal bands (barry). If the stripe was diagonal it was known as a bend, and a number of bands were called bendy.

The function of a modern 'house symbol' is virtually the same as a 'coat of arms'. It is to make the products of the house instantly recognisable in the turmoil of the market place. The symbol of the British Airways Authority is bendy— four diagonal bands.

The principles of simplicity and instant legibility that were

evolved in early heraldry apply to the design of modern devices and letter forms. Good letterers are usually good at designing logo types and in forms of design akin to heraldry.

The more complex heraldic devices came later when armour was no longer effective and when coats of arms became ornamental and genealogical rather than functional as the early ones had been.

To be effective the lines, stripes or bands must be of an appropriate width or scale in relation to the size of the area to be filled or the circumstances of their use. Designing a pattern or border of stripes is not as easy as may be supposed at first. Anybody can cover an area with stripes or make a border composed of lines, but it takes a sensitive and trained eye to make an interesting striped pattern or a convincing and beautiful border made only of lines or bands of different widths or tones.

When a number of thin lines are placed close together (or thicker lines seen at a greater distance) they merge visually

and appear as a tone of grey. This visual merging of one line with another depends on the distance from the eye at which the lines are seen. At one distance from the eye, each line will be seen as a clear, distinct and separate line. But as the eye recedes and the lines are viewed from a greater distance, every line cannot be perceived as a separate entity. The lines become part of a tone of grey. This phenomenon of the visual merging of lines or dots is the basis of the reproduction of photographs. What the eye reads as tones of grey is really composed of dots of varying size at varying distances apart. The dots, even in a newspaper, are too small for most people to be able to see as separate dots at normal reading distance.

This phenomenon must always be borne in mind. At a certain distance from the eye, lines or dots will lose their separate existence to become part of a grey area. The same applies to small type—when viewed from a short distance the lines of type appear as lines of grey and a series of lines appears as an area of grey.

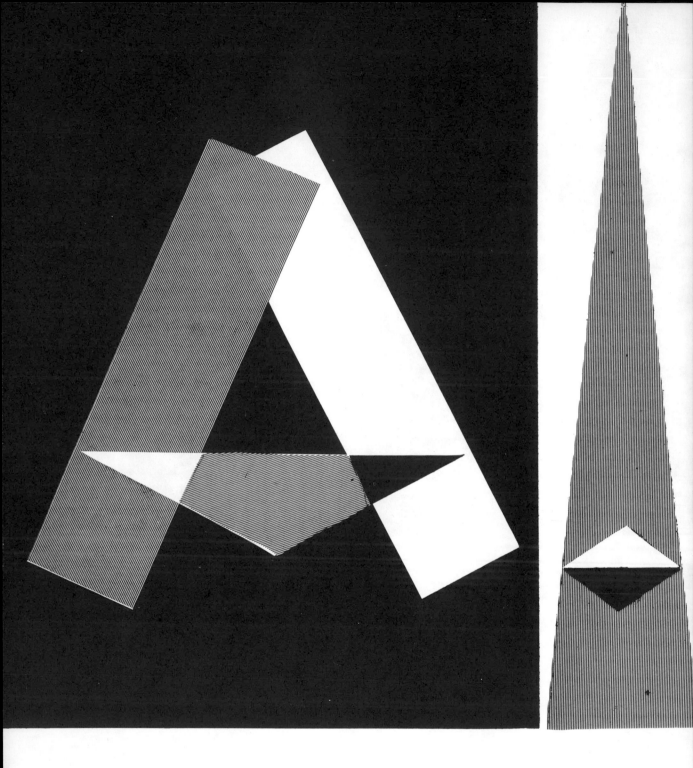

The shapes on this and the following pages, in spite of con-
siderable differences, are all recognisable as the letter A.
ALL ARE A-LIKE UP TO A POINT, BUT SOME ARE MORE
A-LIKE THAN OTHERS.

There is an underlying character or personality to every
letter of the alphabet and each may have a variety of shapes,
all of them readable. But if letters are distorted beyond a
certain point they become illegible and may be ugly too—
but not necessarily so.

Every letter of the alphabet has a personality of its own
which must be cultivated. This personality must be respected
and remembered whenever variations are to be made.

The various forms of cap A shown on these few pages grow
out of the idea that an A is basically a triangle. It is an interest-
ing exercise to create images that are composed mainly of
triangles in a variety of forms and proportions, while still
preserving the identity of the A. As is said later on in this book,
the student will learn a lot by taking a letter and systematic-

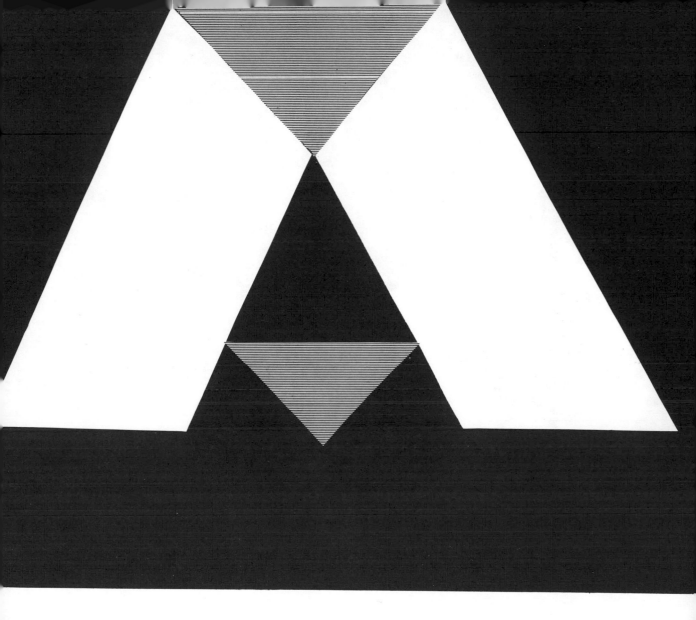

ally destroying its identity. But it is even more challenging to create a striking image that is still recognisable as the given letter.

The variations may be simple and geometric or they may be elaborated into a kind of decoration. A decorative quality is not to be despised, indeed a delight in decoration is one of the qualities which distinguishes mankind from animals. Of mankind, a distinguished anthropologist said—'we know of men without clothes, but of none without decoration'.

The images shown here were cut from black paper with scissors and scalpel. The tones were made with Letratone. Letratone is a self-adhesive transparent sheet on which lines or dots have been printed. This, when stuck onto a white surface, will photograph as though the lines or dots have been printed on the surface. It is easy to cut into shape while the transparent film is attached to its backing. When the backing is peeled off in order to put it into position on the design, it is rather tricky to handle because of the static electricity it

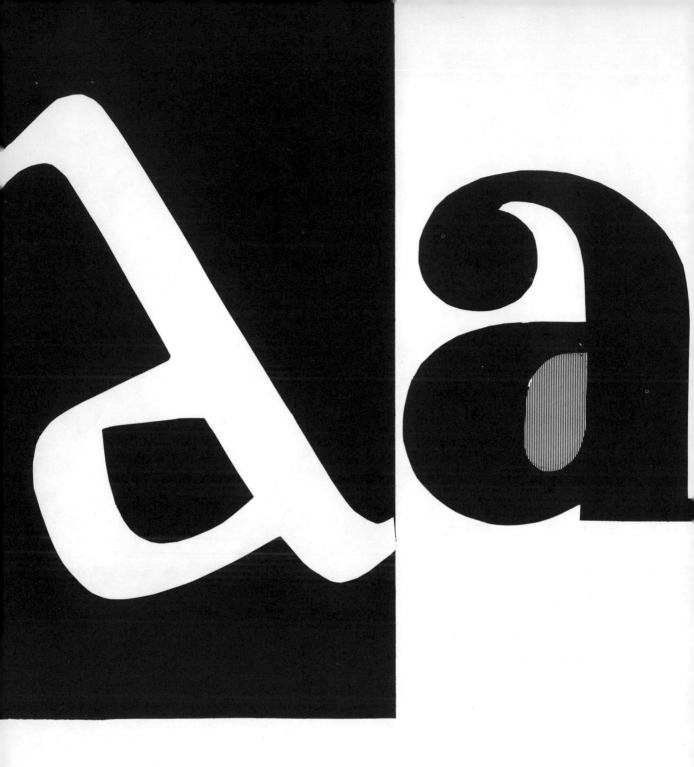

accumulates. It must be handled carefully just before the moment of adhesion because the magnetic effect of the static may cause it to jump suddenly onto the paper; perhaps in the wrong position. But it only requires a short experience to learn how to manipulate it accurately. Letratone is one of a number of proprietary brands of self adhesive screens.

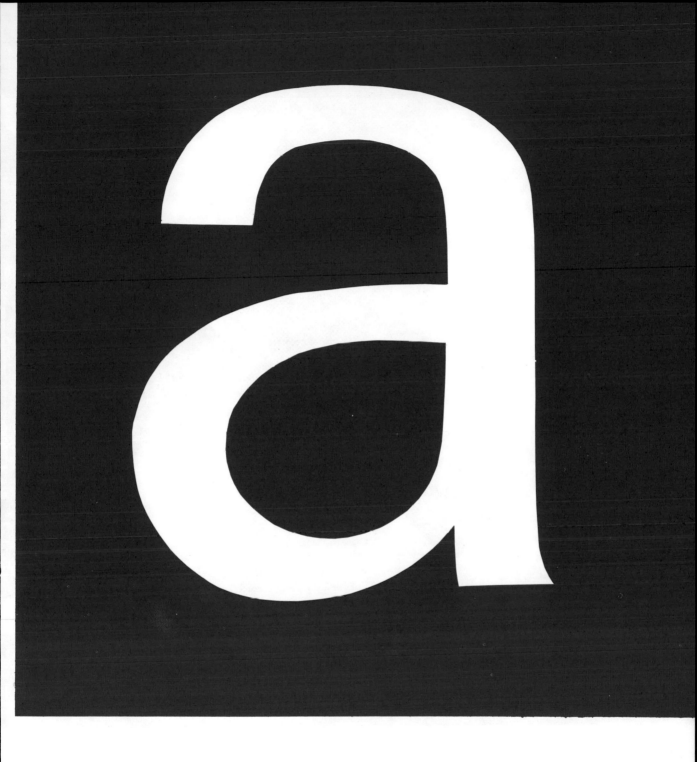

Of course, tones may be obtained with a ruling pen, a Rapidograph, a brush or anything else which will produce a texture of the required tone.

Such exercises not only contribute to an understanding of letter-forms, they also help to train a sense of two dimensional design in black and white and greys.

19

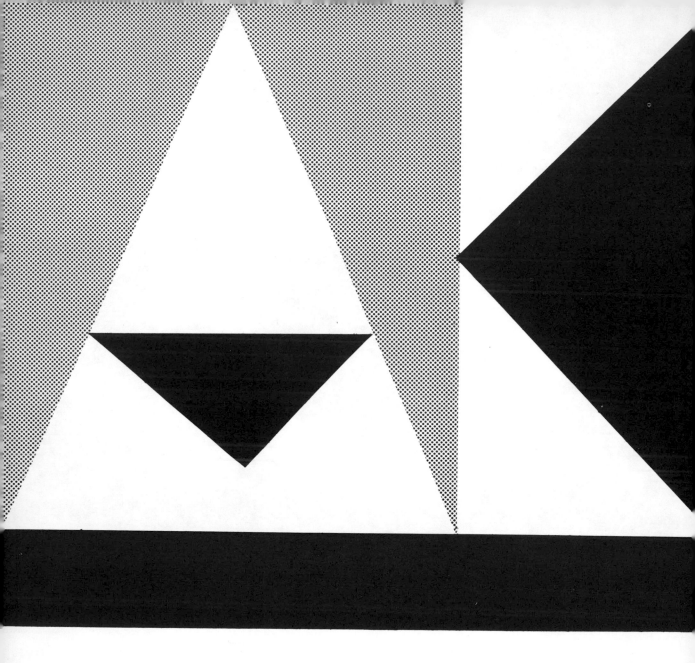

What could be simpler than this sequence of letters. It is just a series of triangles of black, white and grey and yet it makes an interesting pattern which is clearly readable as A, K, M.

The student may like to experiment with other combinations of triangular letters. Many, many variations can be thought of. At this stage, inventiveness is the thing. Do not think too much about legibility but think more about creativity. Creativity may mean not 'thinking' too much but

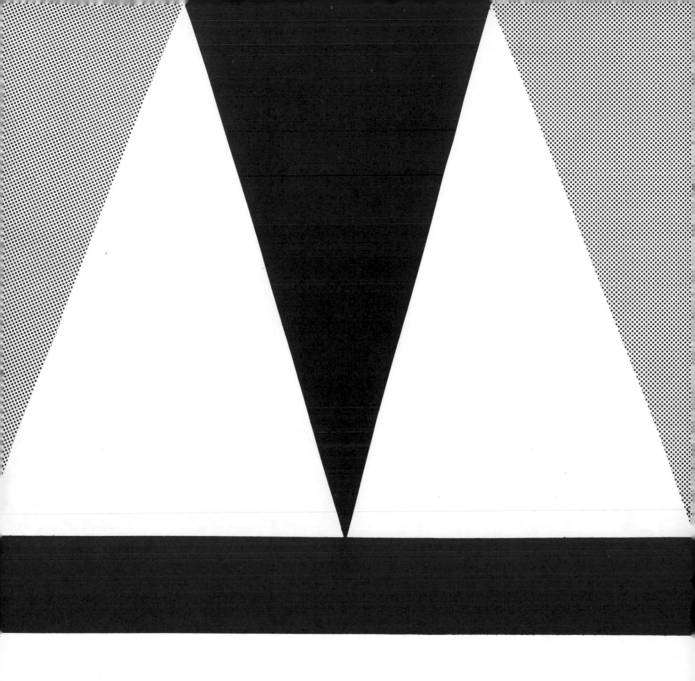

allowing ideas to flow, one idea leading to another without restraint. Too much analysis at the creative stage can be inhibiting.

I remember being told 'create in haste—correct at leisure'. Creativity needs a certain receptivity—the ability to open ones eyes and mind to ideas and to follow where they lead.

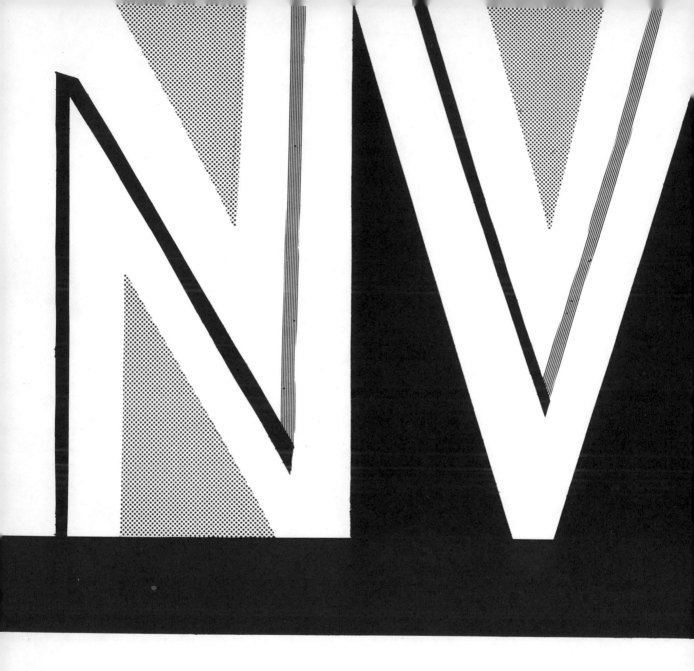

Once ideas, however outrageous, have been put down, they may later be rejected or altered. It was once said that when a child was asked what he thought about something he replied 'How do I know what I think until I see what I say'? I suspect it was an educationist who thought up that reply and put it into the mouth of a child—but it does not alter

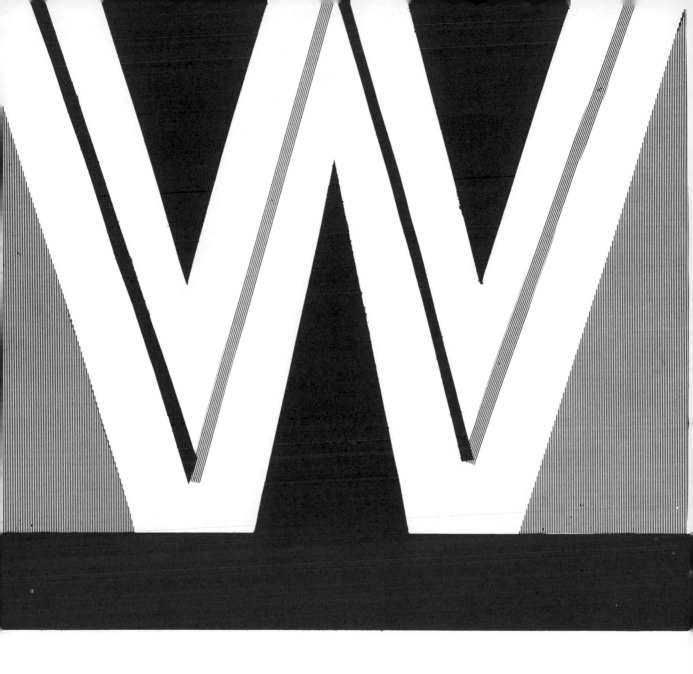

the validity of the idea embodied in that statement. Often ideas do not come until one is actually putting something down, whether it is in words or forms.

Then comes the hard work of refining the idea or of hacking it out of an amorphous mass; but sometimes, while giving shape to one idea, another idea is born.

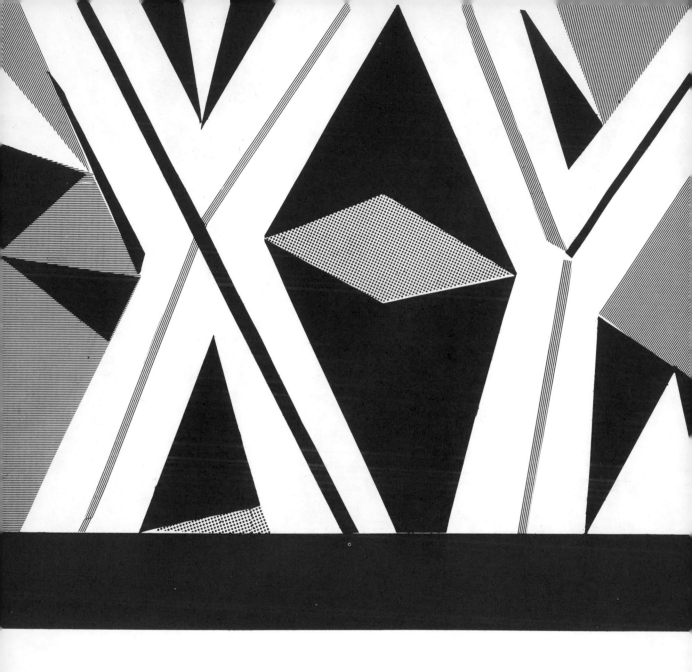

After plain backgrounds to the letters which are relieved by a line running along the stems, interesting effects can be obtained by breaking up the background into triangles. These triangles are related in tone and area with the letters,

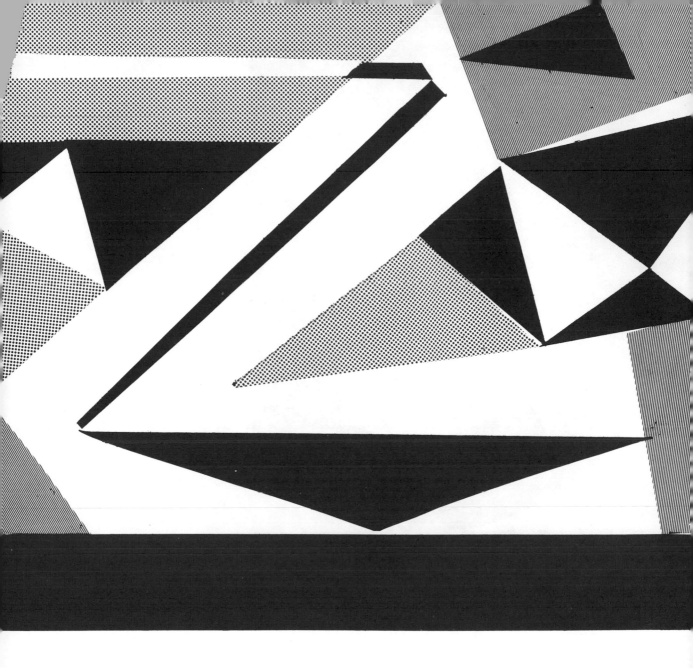

so that there is a homogeneous whole. The X, Y and Z is plainly visible and yet there is a sense of movement between

black and white, a kind of twinkling effect as the eye is drawn first to a white space then to a black one.

25

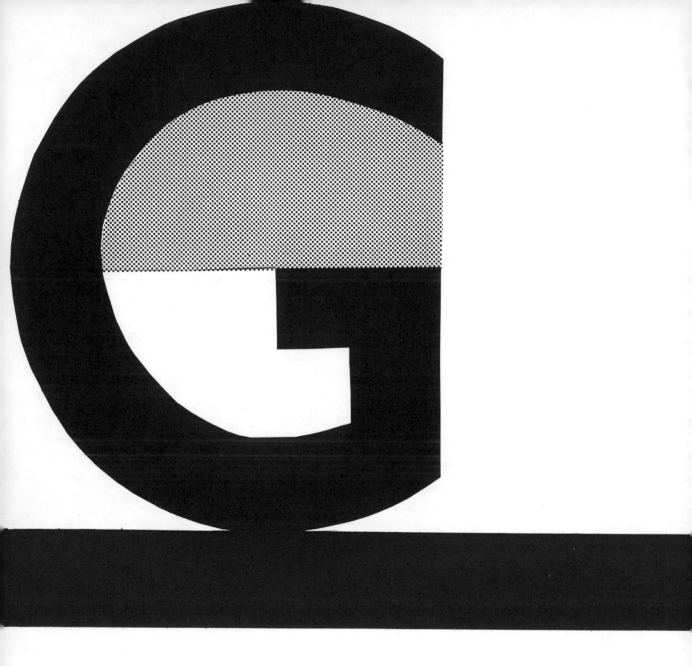

A geometric circle does not make a satisfactory O if it is to be repeated over and over again as in a type for continuous reading. But it can make an eye catching image in advertising. By making half the counter grey and the other half joining

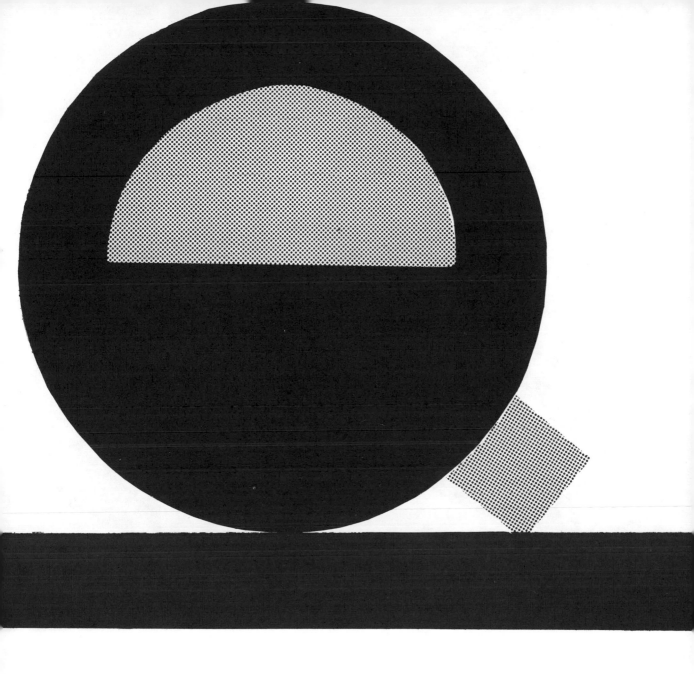

up with the stroke which is implied by the grey half, and by adding a little grey tail, a strong image is formed.

Invent other ways of breaking up the circle or otherwise creating unusual shapes without losing the O.

27

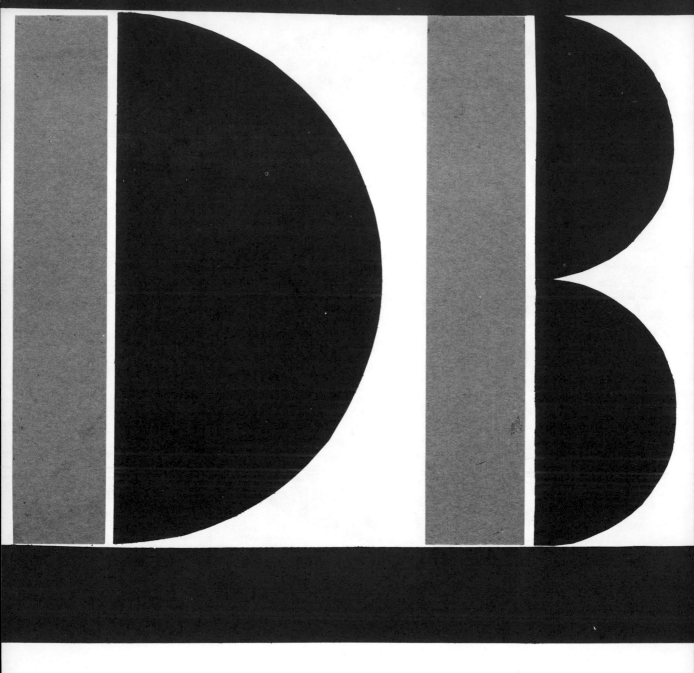

Generally speaking, exact segments of circles do not make satisfactory D's, B's, P's, etc. At least, not if they are to be repeated many times as in a type face. But here quite an arresting effect is produced by using semi circles for the bowls of D, P, B, R—demonstrating that semi circles and straight lines may be recognisable as letters. The change of tone

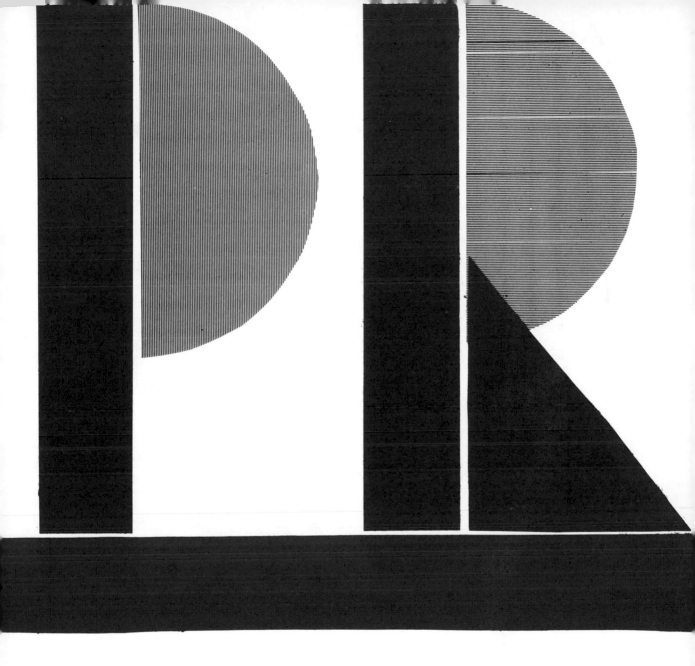

between stem and bowl, and the white line which separates them, together with the background shapes, make an image which might be the initials of a company.

However, do not think at this stage whether your design is commercially viable. Think about creating interesting shapes properly related.

29

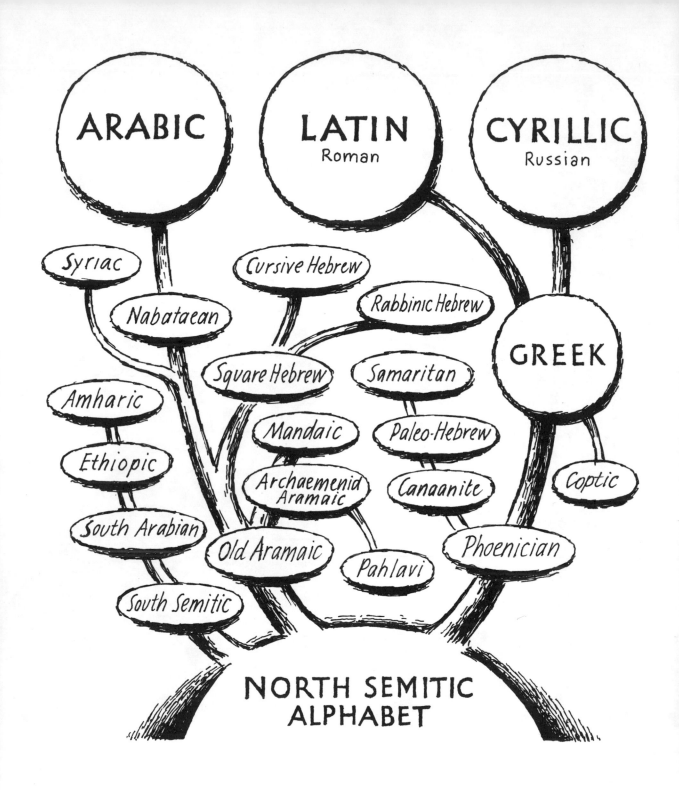

The descendants of the North Semitic Alphabet.

The Historical Approach

'The Past is Prelude'

As already stated, most forms of writing began as pictures of things (pictograms) and today, in places where people from many nations congregate daily such as at airports, we are still inventing pictograms for such things as toilets, cafes, no-smoking and so on. In a sense, a picture of a thing communicates the idea of the thing represented, and many accounts of the development of writing begin with paintings on the walls of caves such as those at Altamira. But can these be regarded as the ancestors of true writing? It seems to me that there is a difference between these 'one off' evocative images (whether or not they have magical significance) and the shapes which are accepted as representing ideas and which are repeated whenever that idea needs to be communicated. Repetition of agreed simple shapes seems to be the essence of writing. This is not present in picture or image making.

Before the invention of deliberately devised signs or symbols which could be arranged in logical sequences, and as such could be called writing, various aids to memory were used. One was the use of tallies or wooden sticks inscribed with notches each of which signified a sack of corn, an ox or any other item, the number of which needed recording. Another method was a series of knotted strings, the number of knots and the colours of the strings indicating very simple facts. But neither method was capable of an extended series of ideas.

Much nearer our idea of writing is the picture-writing of the North American Indians. Here there is great ambiguity and the absence of constantly recurring identical symbols falls short of being true writing. Once the pictorial signs became simplified and consistently employed to represent the same idea, as in the codices of the Maya and early Chinese, we can think of it as writing rather than image making.

A typical evolution of forms from a clear pictorial image to the formal brush strokes of modern Japanese can be seen on page 121. The pictorial origin of many Chinese and Japanese characters is easily recognisable, but as in other forms of writing, some symbols are arbitrary shapes signifying ideas rather than things (ideograms).

Egyptian hieroglyphics began largely as pictograms, some-times used in a rebus-like manner, but signs for syllables and signs for single words were added so that in spite of considerable flexibility to record and express ideas hieroglyphics never quite evolved into an alphabet. They are often so beautiful and interesting that the study of hieroglyphics is both exciting and rewarding. Hieroglyphics could be written both in horizontal lines and in vertical columns—sometimes both ways on the same page or inscription.

The obviously pictorial hieroglyphics were gradually simplified into a calligraphic style known as HIERATIC (literally priestly writing on stone). This in turn evolved into a swifter every-day form of writing called DEMOTIC (of the people).

Precise dates in the distant past are often difficult to arrive at, but Egyptian writing, on the authority of the British Museum certainly goes back to before 3000 B.C.

The idea of a true alphabet was developed somewhere in the area of Syria—Palestine—Israel, probably between 2000 and 1500 B.C. The outcome was the NORTH SEMITIC ALPHABET that was used for Phoenician, early Aramaic and Hebrew. From this sturdy root grew many forms including the three major alphabets of Latin, Cyrillic and Arabic.

In spite of many changes during adaptation to a variety of languages in different cultural conditions, a little of the common origin can be detected in the similarity of the names of the first three letters of the alphabet which can be seen side by side on page 98. For centuries it was the custom to refer to an alphabet by the names of the first two or three letters. We still talk about our ABC. It is easy to see the origin of the word alphabet in the names of the first two letters of the Greek alphabet—Alpha, Beta; in Hebrew—Aleph, Beth; in Arabic—Aliph, Ba.

Resemblances between some of the characters in Egyptian Demotic and North Semitic as used by the Phoenicians leads to the theory that one evolved from the other or at least was influenced by the other. As the Phoenicians were great traders and literacy tended to follow trade (most of the earliest known examples of writing seem to be commercial or domestic), it is thought that Greek developed from Phoenician. Generalisations about the early development of these alphabets must be accepted with reservations, but after the

establishment of the Greek alphabet about 800 B.C. the modifications are mostly well documented.

Although several letters of the Phoenician alphabet are similar to Greek, the fact remains that Phoenician was written from right to left (as Arabic and Hebrew) and Greek from left to right. Inscriptions survive in which the letters run from left to right on one line and from right to left on the next line and so on. This is called Boustrophedon from a word meaning 'ox turning' as the ox turns at the end of each furrow and returns parallel to the first furrow.

The Greeks adopted the left to right direction of writing and evolved an elegant, clear, logical, legible form of capital letter for inscriptions on stone that has never been bettered. Look at the illustration on page 35. How modern this looks. Many of the characters are exactly the same as we use today. They do not look archaic as 'Old English' does for some people. The spacing, placing and proportions are admirable.

When an existing alphabet is employed for a language other than the one for which it evolved, changes must be expected to suit the different sounds of speech. At this point it is well to remember that linguists have stated that 'the number of sounds that can be distinguished as significant in most languages are so few that with between twenty and thirty such symbols it is possible to put most languages into writing'. The Romans took twelve letters of the Greek alphabet A, B, E, Z, I, K, M, N, O, T, X, Y with hardly any change at all, and adapted other Greek letters to make C, G, L, S, P, R, D. The letters V, F, and Q were taken from Greek signs no longer in use. The Romans did not have letters V, W and J. These were added many centuries later; U and W being based on V which was the Latin U; and J was made by adding a tail to I.

The Romans developed the alphabet, particularly for inscriptions in stone, to a point of superlative beauty. One example is, of course, the inscription on Trajan's Column in Rome (A.D. 114), but there are superb examples to be found wherever the Romans settled. Italy, France, Spain and parts of North Africa abound in fine Roman lettering, and here in England the Wroxeter inscription in the Rowley Museum, Shrewsbury is a splendid example of classical incised lettering. A cast of this is in the Victoria and Albert Museum, London.

At their best, the Romans achieved a standard of clarity, purity of form and elegance together with serenity of layout and arrangement that is timeless. They must have had a good method of training their apprentices but it must be admitted that among the enormous number of specimens surviving there are a sufficient number of shoddy examples to show that the Romans too had their unskilled workmen. The astonishing thing is the prevalence of first-class craftsmanship.

With the dearth of documentary evidence as to how Roman craftsmen worked, we must accept the opinion of many present-day expert letterers, that the finest inscriptions were first 'written' on the stone with a broad flat brush which behaved rather like an edged pen, giving thick or thin strokes according to the direction of movement. After the writing was done, the letters were cut in stone with a chisel by a skilled mason.

Some people think that the serif is the outcome of the need to start and finish a stroke crisply whether with a broad brush, pen or chisel. (Or did serifs appear and endure because people liked them?) Though we associate the classical serifed form with Roman lettering it is surprising the number of other styles that were practised in Roman times.

Before we trace the changes in Roman letter forms from about A.D. 200 to the present time, let us consider for a while the oldest form of writing known which grew up in that part of the Middle East in the basins of the Tigris and the Euphrates in Southern Babylonia or Sumer. This is CUNEIFORM so called (Latin *cunius*—a wedge, and form-shape) because it is made with a wedge-shaped stick or stylus on tablets of wet clay that were then baked. This is a durable material that may be broken, but it does not easily disintegrate. Because of the durability of these clay tablets on which were written records not only of affairs of state but of every-day domestic matters so that we know more detail about the daily lives of the Sumerians than we do of many medieval communities two or three thousand years later. The earliest known cuneiform documents are dated to about 3100 B.C. and the latest to around A.D. 100.

The system was based on the wedge shapes being arranged as in an imaginary circle, like a clock, the significance depending on their position. Assuming that the stylus was held in the right hand (and mankind always seems to have been largely right handed) it is obvious that strokes are much easier to make that fall in the top left-hand sector of the circle—from 9 to 12 o'clock. As a consequence, most, but not all, of the strokes which make up the letters of the alphabet are placed in those positions.

Many cuneiform examples, usually in tablets not much bigger than the two hands can make by patting a handful of clay; or in cylinders or hexagonal prisms, were very beautiful. The scribes had a remarkable sense of texture and layout. The *mise en page* of some examples looks surprisingly 20th century and certainly inspiring to any lover of lettering.

The cuneiform system was adapted by the Akkadians to their own Semitic language early in the third millenium B.C. and for centuries cuneiform was the only international script. The technique was also the basis of the old Persian Syllabary and the Ugaritic alphabet. Cuneiform script survived for three thousand years into the Christian era. The surprising thing to me is that it survived so long when not so far away in Greece and Italy a more convenient method of writing had evolved.

From the peak of the classical Roman period down to the present day the broad changes of style of letter forms can be traced without much difficulty. Changes in shape are influenced by the tool or instrument (brush, pen, chisel etc.), the material (stone, wood, metal, papyrus, parchment etc.) and, of course, by the general artistic climate of the period. Lettering is always related to the architecture, painting and decorative art of its time. Often lettering can help date other objects d'art.

The norm or highest standard of lettering in Roman times is to be found cut in stone and marble. These letters are still among the finest ever produced and are among the best on which the student can base his understanding.

Lettering for legal, commercial or domestic use was made with a reed pen on papyrus; ephemeral jottings were made on a wax tablet. This affected cursive forms of writing. Roman cursive writing was often very free, letters ascending and descending in decorative flourishes and extensions.

The advent of an edged pen gradually changed the detail of form as the scribe began to model his letters on the stately lapidary inscriptions on buildings. Such formal, slowly-made letters are called Quadrata or Square Caps. But a style of writing, more true to the pen, was evolved which is now called Rustic. Rustic caps (there were no 'small letters') are condensed and made with the pen's edge almost at right-angles to the line of writing so that verticals tend to be thin and horizontals

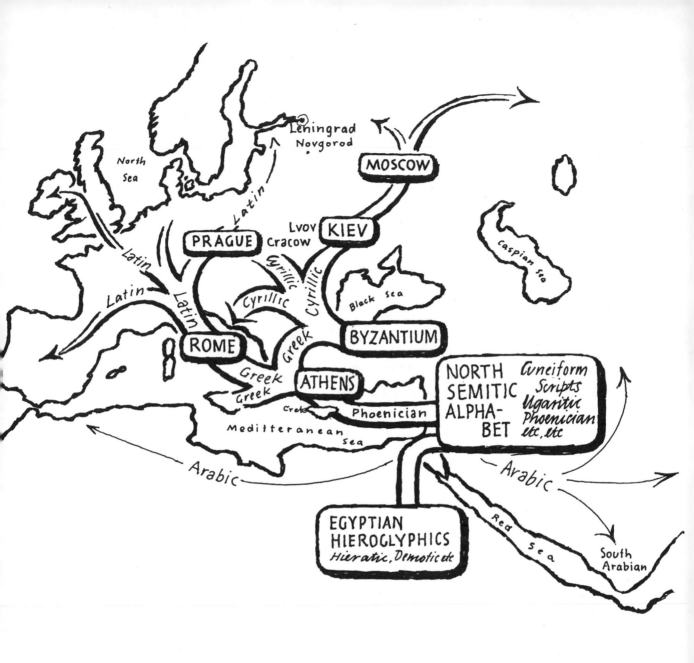

The path followed by the chief descendants of the North Semitic Alphabet.

The Greek alphabet was adapted as it moved north-east into Byzantium and further north into Bulgaria, Poland and Russia until Cyrillic emerged as an alphabet in its own right. Greek was modified in Italy and the Latin alphabet was established. This Latin alphabet which we also call Roman, is still basically the same as it was over two thousand years ago.

33

thick—very conspicuous in letters like E.

Though the early scribe took his forms from the mason, the success of Rustics led to masons cutting them on stone even though Rustics are essentially pen forms. Rustics appear again and again and nowhere more beautifully than in the magnificent Alcuin Bible from Tours about A.D. 800. The next landmark in the development of Latin script is the genesis of uncials. This is a stately letter with only a few slight ascenders and descenders, but with an abundance of broad curves in letters like D, E, H, U, M. Uncials have had a minor revival in recent times. They appear in many forms of publicity and Victor Hammer has designed an uncial type which deserves more frequent usage.

Uncials are still basically 'caps', but gradually the ascender and descender increased until the style we call 'half-uncial' emerged. Half uncials reached a peak of magnificence in the Lindisfarne Gospels and the Book of Kells (8th century). These are great works of art by any standard. This Irish half uncial is also known as 'Insular' or Irish-Anglo-Saxon.

The Book of Kells, now in Trinity College, Dublin, has superlative illuminated initials and opening pages to Gospels, but the half-uncial of the text is one of the most beautiful book scripts in Europe and maybe, the world. Half-uncials became the national hand of Ireland and its influence is still to be seen on public notices and as a printing type in Eire.

Half uncials in other countries were less monumental and more utilitarian, leading to the crisp minuscule of about A.D. 800 onwards. This minuscule, known as the Caroline, Carlovingian or Carolingian minuscule is so-called after the Emperor Charlemaine (Carl). He invited a scholar, Alcuin of York, England, to be Abbot of St Martin's at Tours in A.D. 796 where Alcuin remained until his death in A.D. 804. While there, revising the texts and supervising the writing of manifold manuscripts, a style of writing was evolved that set a standard of simplicity, clarity and legibility for the whole of Europe. Indeed it can be regarded as the direct ancestor of the types we read today.

It is natural that the Caroline minuscule should develop local variants in different countries and have been named accordingly Merovingian (Frankish) Lombardic (Italian) and Visigothic (Spanish). Variations of the Caroline minuscule continued through the 11th century sometimes in a rounder form that relates to the round arch of the Romanesque architecture of the period. Gothic architecture during the next few centuries had narrower pointed arches and there is a corresponding resemblance in the writing which became narrower and more angular until what is known as Black Letter or Textura was established throughout Europe. The term Gothic is unfortunate in the language of lettering. In architecture it was originally a pejorative term applied by Classicists to Gothic architecture which they regarded as barbarous like the Goths. But in typography 'Gothic' is also applied to some sans serif types. So the terms Textura or Black Letter are much better though sometimes the word Gothic can be appropriate. In the 15th century when the Caroline Minuscule was revived the type derived was sometimes described as 'white' letter in contrast to the strong tone of black letter.

Black letter was the current hand when Gutenberg invented a practical method of casting identical types and made printing from moveable types a commercial process. Gutenberg's types are so near to the hand-writing of his time that a page of his famous Mazarin Bible might at first glance be mistaken for a manuscript. Some printers were proud that their books looked so splendid and boasted in colophons that they were done without the aid of reed or quill. But the initials and decorations were made by hand, indeed, the dating of the forty-two line Bible is arrived at from the date given by the scribe when he completed the rubrication. No printing exists with Gutenberg's name on it to confirm that it was his. But as early as 1438 he was sued for money lent for experiments in printing. The official date used for centenary celebrations of the birth of printing in Europe is 1440. By any standards Gutenberg's Forty-two line Bible is a masterpiece. Black letter or Textura and its derivatives such as Schwabacher and Fraktur survived in Germany into the 20th century, indeed it is alive today to a limited extent. But in other countries Black letter was superseded by 'white' letter, that is, Roman type.

During the Renaissance when classical authors were being re-discovered, many of the manuscripts were in the Caroline minuscule and this led to revival of this style of writing which became known as Neo-Caroline or Humanistic. It was this Humanistic script which was current in Italy (as well as a semi gothic letter) when printing was introduced in the second half of the 15th century. It became the model on which the types of the two most famous Venetian printer-publishers, Aldus Manutius and Nicholas Jenson were based. Jenson's types have been used as a basis for a number of 20th century types such as Centaur and Cloister. Aldus Manutius, a scholar printer, employed Franceso Griffo to cut his types. The type first used to print a tract by Cardinal Bembo was recut (or refashioned) by the Monotype Corporation in 1929 as the type we call Bembo. It is still one of the best available book types. Aldus also engaged Griffo to cut the first italic type in 1500.

Printers became proud of their art and craft and there was considerable interest in letter design and in writing well. So much so, that in the 17th and 18th centuries a large number of books on writing were published. Some of them are available today in relatively inexpensive facsimile.

The scribes, who were eventually to be made redundant by the printing press, nevertheless produced some magnificent writing during the first century after the invention of printing from moveable types. Fortunately some of them recorded their method in printed books. Among the most famous and influential writers are Ludovico Arrighi (Vicentino), Giovanni Antonio Tagliente, Geoffrey Tory, Juan de Yciar, Albrecht Durer, Wolfgang Fugger.

The style of letter favoured by Aldus was gradually modified by successive type cutters in the 16th century, among them Claude Garamont or Garamond, Estienne, Plantin and Granjon whose fame lives on in the names of 20th century types. The diagonal stress, the sloping serifs in the lower case and other subtle characteristics of these types, together became known as 'old face' (Geralde). During this century copper plate engraving gained favour in book illustration that often required lettering as captions.

The pointed flexible pen came into use and changed the character of the writing. At the end of the century De Beaulieu published in 1599 an engraved copy book which some people regard as the starting point of the long life of 'copper plate' letter-forms.

In the 17th and 18th centuries the Writing Masters produced a splendid assemblage (they might have called it a galaxy) of writing manuals, some with titles as grandiloquent as their flourishes were ornate. They delighted in sweeping curves, fine hair lines swelling with virtuosity into elegant accents.

They appeared all over Europe, but among the best were the English masters Martin Billingsley *The Pens Excellency or Secretaries Delight*, John Ayres *A Tutor to Penmanship*, George Bickham *The Universal Penman* and many others.

Type faces and even grave stones showed this taste for fine hair line serifs, smart curves and vertical emphasis. This tendency culminated in the types of Bodoni of Parma in Italy. His types are among the best models for 'modern face' letters.

Although the latter half of the 18th century saw the establishment of 'modern face' the first half of the century is remembered as the time of William Caslon, the engraver of gun barrels who produced one of the finest 'old face' types ever—Caslon Old Face. Fashions in types come and go but Caslon lives quietly on.

types today, and the hand printing on handmade paper or vellum could not be economic—nevertheless his spirit of perfection in scholarship, craftsmanship and materials is timeless.

Emery Walker himself together with Cobden Sanderson set up a private press 'The Doves' which was dedicated to a form of perfection which was as austere as Morris's was extravagant. Plain initials in colour were as near as Emery Walker got to decoration. His text type, also based on Jenson, was clear, open and with little or no contrast in the thickness of the strokes, apparently in reaction to 'modern face'.

The Kelmscott and the Doves were the most important of many private presses which followed. The Arts and Crafts Movement and the emergence of Art Nouveau occurred at

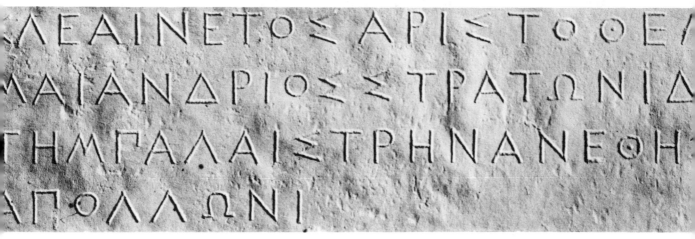

A dedication of the Palaestra Naukratis. About the 3rd century B.C.

Caslon was followed about the middle of the century by John Baskerville, writing master, manufacturer of Japanned trays and snuff boxes, and quarrelsome free-thinker. His type is transitional between 'old face' and 'modern'. He became one of the best book printers in the country. His type has been recut many times and remains one of the best book faces.

During the 19th century a multiplicity of styles of lettering flourished. Modern face continued to be used in books, but advertising was a growing industry. On posters and play-bills modern face grew into Fat face with fine hair lines and elephantine stems. Slab serif letters appeared on buildings, in type founders specimen books, and on grave stones. Sans serif letters also were used on buildings, memorials and posters. Considerable phantasy and invention was displayed on title pages and on initial letters. There was an exuberance of design that eventually led to a reaction.

The Fin de Siecle was not a period of emasculated aesthetes as might be thought from Gilbert's libretto of *Patience*. It was the time of the arts and crafts movement and William Morris. William Morris was a wealthy gentleman-socialist who was so dissatisfied with the types and standards of printing available for his books that he set up a press of his own. With the technical advice of his friend Emery Walker he founded the Kelmscott Press in 1891 and employed E. P. Prince to cut special type faces based on 15th century letter-forms. Though his types are hardly to be used as a foundation for

a time when the basis of our society was being questioned and people were beginning to search for new ways of thinking. William Morris had seemed to be looking back to the middle ages for ideas on which to found a new society. Happiness and peace was to be found by making things by hand. The machine threatened to be a hard task master. He, and others in the Arts and Crafts Movement, seemed to have forgotten that all printing (apart from individual burnished wood engravings) was by machine, albeit hand operated, and was basically 'mass production'. A type is designed to be cast in moulds thousands or even millions of times without perceptible deterioration of form. This is indeed mass production, yet no one doubts that types can be beautiful.

Eventually it was accepted that a machine could produce aesthetically acceptable things, though some craftsmen still regard the machine as a kind of enemy. But a machine can only produce what is designed for it and designs have to be made by hand no matter what material they may later be manufactured in.

There was a revived interest in lettering and the man who in England had a very great influence which spread to the continent was Edward Johnston. He was a brilliant penman and a great teacher. His book *Writing and Illuminating and Lettering* first published in 1906 is perhaps the best book on the subject published in the 20th century. But one of his most important achievements was his design for a sans serif letter

VOTVITVRATERODORT
INTVSSAXASONANI
ACCIDITHAECEESSISET
QVAETOTAMIVCTVCO

Rustic capitals. About the 5th century A.D. (enlarged). One
of the first true pen forms.

uberib:caprarum·autoui

rum manu praessis· longa

piosilacaseffluere! pu

xit incolomis·'Nosobsu

ntaereimiraculo. idquoc

The Caroline Minuscule about 9th century (enlarged). It is easy to see this as the ancestor of our lower-case.

36

QVINTI

HORATII FLACCI

OPERA.

VOL. I.

LONDINI

AENEIS TABVLIS INCIDIT

IOHANNES PINE

MDCCXXXIII.

Title page to John Pine's Works of Horace, 1733. The whole book, including the text of some 265 pages, was engraved on copper-plates—one for each page.

Aa lll a lll a lll a lll a

A B C D E F G H I J

Aambmcmdmemoefmffmgmhmimjmkmlmllmm

nmompmpmqmrmsfsmfmttmumvmnmxmymzm

K L L L M N O P P 2

Gentle and prudent Reply to indecent and scurrilous

Language is the most severe tho innocent Revenge.

R S T U V W X Y Z

George Bickham 1730

Aaabbccdeeoefiffghij

nnooppqrrsfsttuvnv

Praefatio.

venuftum et antiquitatis ftudiofis acceptum reddi poffe videretur, curatum eft, ut, quae-cunque in ftatuis, toreumatibus, et nummis archetypis ad Horatiani argumenti illuftra-tionem idonea comparari poffent, fuis quae-que locis infererentur.

Textvs ad exemplar Cantabrigienfis editionis anno MDCCI in duodecimo Iacobi Talbot S. T. P. opera vulgatae, quae eru-ditis plerifque ob accuratam in corrigendo diligentiam placuit, conformatus eft.

Ingrati effet animi non palam ag-nofcere, multum adjumenti a nobiliffimis Penbrochiae et Burlingtoniae comitibus, Andrea Fontano equite aurato, Richardo Meado medico regio, et Thoma Sadlero armigero, in habendo omnigenae fupellecti-lis antiquariae delectu ; atque adeo in ipfo opere undiquaque exornando ab aliis quibuf-dam eruditione atque ingenio praeftantibus viris, quos inter Thomam Bentleium L I. D. quin nominem temperare mihi nequeo, alla-tum fuiffe.

Vale, lector : tua fac aequanimitas ar-tificis induftriam augeat ; et fi quando de-prehenderis errantem, hos effe primos in re fatis ardua conatus memineris.

SUBSCRIBERS.

His Royal Highnefs
FREDERICK
Prince of Wales.
His Royal Highnefs
WILLIAM
Duke of Cumberland.
His Moft Serene Highnefs
W. C. H. F.
Prince of Orange.

Nobili et Honorando admodum Viro

ROBERTO WALPOLIO,

Nobiliffimi Ordinis a Perifcelide dicti

Commilitoni,

P R I M V M

Horatii Carminum Lib.

D. D. D.

Johannes Pine.

QVINTI
HORATII FLACCI
CARMINVM
LIBER I.

ODE I.
Ad Maecenatem.

AECENAS atavis edite regibus,
O et praefidium et dulce decus meum,
Sunt quos curriculo pulverem Olym-
picum
Collegiffe juvat ; metaque fervidis
Evitata rotis, palmaque nobilis 5
Terrarum dominos evehit ad Deos.
Hunc, fi mobilium turba Quiritium
Certat tergeminis tollere honoribus ;
Illum, fi proprio condidit horreo
Quidquid de Libycis verritur areis, 10

Two double-spreads of Pine's 'Horace' showing a typical text page and the opening to Book 1 of the odes. This book is a tour-de-force, not only of lettering and engraving but of clean, crisp, consistent printing from hand-wiped copper plates immaculately placed on the page.

Calligraphy by Rudolph Koch.

in 1916 to be used by London Transport on the Underground railway and still used not only on the Underground but also on London's buses and coaches.

From that time the interest in sans serif grew. At first people disapproved of letters without serifs on buildings and even in 1929 Master Printers did not take kindly to Gill Sans.

But with the enormous increase in printed matter where bookish styles were irrelevant, sans serif letters became very popular.

I have taken it as an axiom that in Roman times the norm for lettering was the inscriptional letter, in medieval times it was the letter written with an edged pen, and in the 20th century it is the printed letter on which our ideas of what letters should look like are based. Certainly it is in the field of type design that most of the best letterers are to be found, though they may also work in other media. Eric Gill is a good example. He worked for years as a cutter of inscriptions on stone, as an engraver of initial letters for books, and as the designer of Gill Sans and the classical Perpetua type and many others.

In Germany two people had disciples comparable to those attracted by Johnston and Eric Gill in England. They were Rudolph Koch and Von Larisch. Von Larisch came from Vienna where his *Unterricht in Ornamentaler Schrift* was pub-

lished in 1905. Whereas the essence of Johnston's teaching was a discipline in simple letter formation with an edged pen based on historic writing styles, Von Larisch encouraged students to use any tool or material in which letters could be made in order to foster creative ability. His influence is alive in the art schools today though his name may not be well known, at least in England.

Rudolph Koch was a calligrapher and type designer at the Klingspor Typefoundry and a profound and influential

those still in use are Kennerley, Goudy Old Style and Goudy Text which is a very satisfying black letter. His book *The Alphabet and Elements of Lettering* is an admirable and valuable handbook for the aspiring letterer. There were, and there are, many creative letterers in America, among them W. D. Dwiggins; Bruce Rogers, whose type Centaur, based on Jenson, is a first-class book-face; Oscar Ogg; Alexander Nesbitt; Arnold Bank, Donald Anderson and Father Edward Catich.

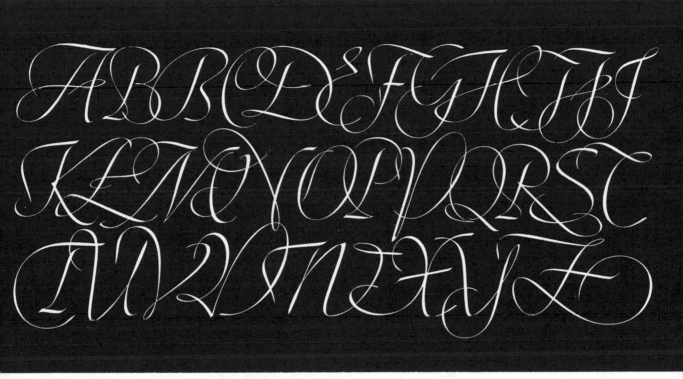

Alphabet by Hermann Zapf engraved on metal by August Rosenberger.

teacher at the School of Arts and Crafts in Offenbach. His class grew into a workshop community or Werkstattgemeinschaft where people worked singly or in groups to produce books, tapestries and other artefacts which involved letter forms. Koch's personality shines through all his work whether with the pen, the graver or punch cutter's tools. As most of his best work is in Fraktur and other Black letter forms his influence on roman lettering is perhaps less than that of E. R. Weiss who worked for the Bauer Typefoundry. Germany has always been notable for calligraphic fecundity but Holland too, has from the beginning of printing in Europe produced a succession of fine letterers, type designers and printers. Holland has even claimed that Laurents Coster of Haarlem printed from moveable type before Gutenburg. Be that as it may, Haarlem is still a centre for fine printing and typefounding at Enschede en Zonen. Jan Van Kimpen created fine classical book types such as Lutetia and Spectrum.

In America, probably the greatest and certainly the most prolific type designer and letterer was Frederick Goudy (1865–1945). He produced over a hundred types and among

One of the greatest living practising letterers is, to my mind, Hermann Zapf. His calligraphy is both imaginative and restrained, dignified and playful. His type designs belong in the great classical tradition and yet they are essentially of the 20th century, and of the second half of the century at that. His influence is justly wide. One sees the influence of his types Optima, Sistina and Melior on books and television screens. As will be seen on page 117 he designs in Arabic with the same finesse as in the Latin alphabet, and his Cyrillic is one of the best ever. Anything by Zapf is worth studying.

In the same company one must place Adrian Frütiger, famed for his sans serif type Univers produced by Deberny and Peignot between 1956 and 1958.

To me it is very significant what Zapf says about the shape of letters to come 'The type of the future will surely more and more strip away the historic style elements of the past, yet without descending to a geometric abstract form of letters. For the optical requirements remain the same so long as the letter images are still received by the human eye and not exclusively by an electronic reading machine.'

how much is
expendable

abcdefghij
klmnopqrs
tuvwxyz

An alphabet designed by Brian Coe as part of an experiment to determine how much of each letter of the lower case alphabet could be eliminated without seriously affecting legibility. Compare with Cassandre's Bifur on page 95.

The Legibility Approach

Webster's Dictionary definition:
LEGIBLE: 'Capable of being read or deciphered; distinct to the eye; plain—used of writing or printing.'

There is now a lengthy literature on legibility, much of it couched in such esoteric language that it is not surprising that most designers are unwilling to devote much time to the study of these often painstaking experiments. So far, at least, scientific research has produced little which is of practical value to the practicing letterer and typographer. Which is not to say that such research should not go on. On the contrary. But it is good that some of the research is being carried out not only in the laboratories of experimental psychologists but in the Royal College of Art, London, by Herbert Spencer RDI, RSIAD, Senior Research Fellow in the Readability of Print. His book *The Visible Word* is perhaps the best available work on the legibility of print in a language and form acceptable to designers. Its bibliography is very extensive.

In his summary there seems to me nothing which was not already known to the experienced letterer-typographer with a sensitive eye. But it is assuring to see experience justified by experiment.

It seems to me that the eye is the final arbiter of what is a satisfactory letter-form, because 'satisfactory' means more than the strict psycho-physiological perception. It has long been known to good designers and typographers that 'words set entirely in capitals are considerably less legible than words in lower case, that italics reduce legibility, but provided the counters of the letter are open, bold face does not'. Some people prefer semi-bold types; for people with poor vision it is essential.

Excessively long lines cause a sharp increase in the number of regressions (reading the same line twice). Short lines, on the other hand, increase the number of fixation pauses.

Leading (space between lines) permits longer lines without loss of legibility.

There is no appreciable loss of legibility when type is printed in black ink on tinted paper provided this is of seventy per cent reflectance or more. Black print on white is more legible than white on black. Hurrah! Unjustified setting (where the right-hand margin is irregular as in typing) does not decrease legibility.

Commonsense will suggest many of the factors relevant to legibility. Here are a few; all are related or interrelated:

Size Large letters are generally speaking (obviously) more legible than small ones.
Distance from the eye Legibility diminishes with distance.
Illumination The brightness and quality of light by which the letters are read affects the legibility.
The nature of the surface of the background of the letters, whether highly reflective or not has an influence on legibility.

Some of the experiments in legibility deal with the measuring of these physical factors—but psychological factors are also relevant. For example—fatigue. Is the reader fresh or tired. Do some of the above factors induce fatigue? One experimenter measured the number of times a reader blinked while reading and ranked types by their blink rate. The more the reader blinked the less good the type!

Is the reader familiar with the subject matter or with the letter form? Readability is not just a matter of the mechanism of the eye processing the stimuli it receives, but of understanding the reading matter. A reader interested in a subject will tolerate or ignore physical barriers or difficulties. Lack of interest tends to decrease swiftness of comprehension or reading efficiency. Nevertheless, there are a number of physical phenomena or optical illusions which have a bearing on the design of letters as will be seen on the following few pages.

Optical illusions cannot be dismissed as parlour games. They are facts, they are phenomena that have to be reckoned with when designing anything in which appearance matters. They are particularly relevant in the design of letter-forms and especially in the design of printing types.

A square which is geometrically square looks slightly wider than it is high and therefore must be increased in height in order to *appear* square. We are concerned with appearances. Forms must *appear* right; indeed, it is only right if it appears right. The designer must be for ever on the alert to detect when a form does not look right because of the illusions that are due to the physical nature of the eye and how the phenomena are interpreted by the mind.

A trained eye is superior to purely geometric construction.

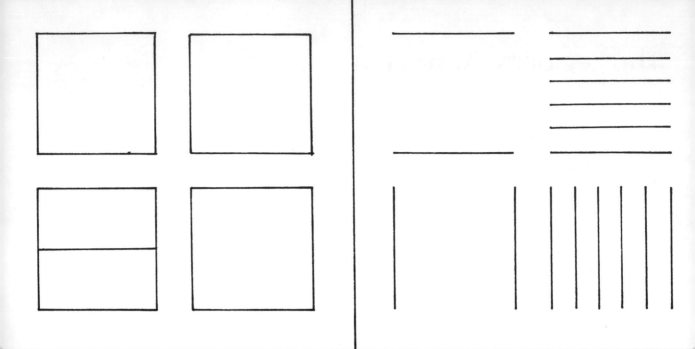

A geometrically precise square tends to look greater in width. To appear right, the height must be slightly greater than the width.

When a square is divided horizontally into two equal parts, the lower half looks smaller.

When a tiny square dot is drawn the corners tend to appear rounded. The smaller the dot becomes the rounded corners tend to merge and the dot appears to be round not square.

When a horizontal line is placed at the upper and lower boundaries of a square, the square looks wider.

When lines are placed vertically at the boundaries of a square, it looks slightly higher than it is wide. But when a square is filled with horizontal lines or bands the square tends to look taller. A square filled with vertical lines has the effect of looking wider.

For the eye and mind to be satisfied, many subtle adjustments must be made to the product of ruler and compass though both those instruments may be useful. Though there is a considerable rational element in lettering, reason alone does not provide all the answers to our questions. We have an aesthetic sense as well as a faculty for reasoning and in the last analysis, it is the aesthetic sense which prevails.

By an aesthetic sense I do not mean that knowledge and reason is overriden by a desire to produce the beautiful. On the contrary. The foundation of good design is in the assembly of the relevant facts and constraints and making reasonable judgements based on all the available data. But visually, when making a selection between alternative forms, the final choice is intuitive. But intuition in this sense does not mean arbitrariness. Intuition can be trained and disciplined. In this context it means training the eye by a sensitive study of accepted letter-forms in any script, in any medium, in any context.

This line of argument can lead to the historical approach. As history provides the great reservoir of letter-forms, and history means the recent past too, the argument concludes that by studying historical examples all one need do is take them as a basis for new designs. There is no doubt that this attitude has produced many good designs in the past, but times have changed. More information is available about the physiology and psychology of perception which must be taken into account. And though the study of the history and development of letter-forms seems to me to be vital and necessary, it is also important to study the phenomena associated with legibility.

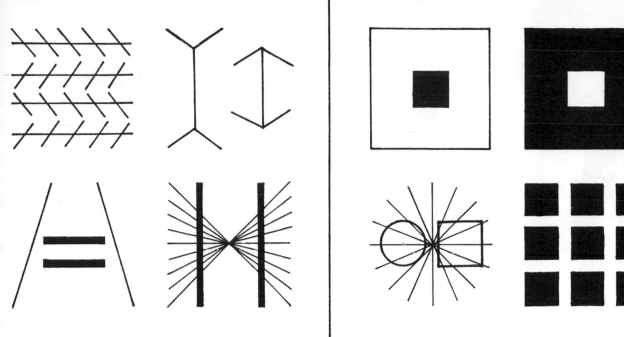

Parallel lines, when crossed diagonally by other lines, do not appear to be parallel.

The two vertical lines are of equal length. That with the outward pointing fins appears longer than the one with inward pointing fins.

Two black lines of equal length appear unequal if enclosed by converging lines.

Parallel lines appear bent when crossed by converging lines.

The black square surrounded by white seems smaller than when the square is white surrounded by black. The white irradiates beyond its boundaries.

The circle and square appear to be distorted when superimposed upon radiating lines.

Where the white bands cross there appears to be a misty grey image.

Pattern in Islamic Art

Compare the line above with the line below. They are the upper and lower parts of a line of letters cut through the middle. The upper half of the line is quite legible; the lower half is virtually impossible to read.

Pattern in Islamic Art

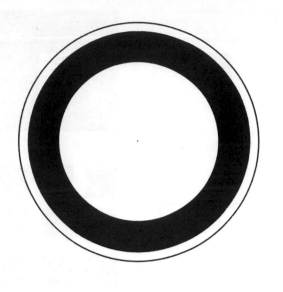

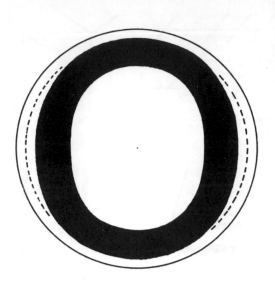

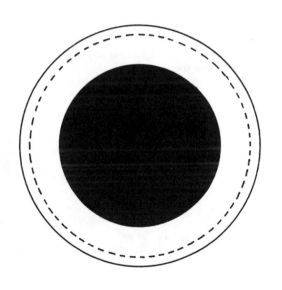

Above it is obvious that an exact circle does not make a completely satisfactory O. The counter, of course, is also circular. If the letter is made slightly narrower than it is high, and if the stroke is made slightly thinner at the top and bottom, the result is much more pleasing. The difference in shape between the two counters is enormous. One is uncompromisingly circular, the other is definitely oval. This diagram also shows how the curve at the bottom goes beyond the base line a trifle more that it projects above the cap line, or mean line if it was a lower case O.

46

When type is photographed in photo-setting machines corners become rounded and the original drawing must allow for this. In order for the external angles to appear square they must finish as finely tapering points as shown above. Enclosed angles require a small recess in order to photograph as a sharp angle, as in the above H and E.

Letters like V would appear too heavy at the junction between the two strokes if they met unmodified as in A. To overcome this, the counter is extended a little as in B.

A Method of Practice

The teaching of lettering during the last twenty years has changed with the reorganisation of art and design education. The whole attitude to the teaching of arts and crafts has been revolutionised and methods of teaching have been radically altered. The old authoritarian method of putting something in front of a student and saying 'Copy that—because we say so' is gone.

Today the attitude is now analytical and exploratory, with more responsibility given to the student to find out for himself and to have the freedom to select what, where and how he studies. This has not, for all students, proved the best way of acquiring knowledge and skills, indeed some have felt quite lost, but there is little doubt that the analytical and experimental method of teaching (and learning) is more suited to present-day conditions.

Lettering used to be taught by giving students a specimen alphabet and after a little talk and perhaps a sketch on the blackboard, telling them to copy it as carefully as possible. This was repeated with other styles of alphabet. Rarely were students encouraged to ask such questions as 'what *is* an alphabet'? Is an alphabet the only way of recording ideas? Is it the best way? If it is, what is the best form of alphabet? How did it come into being? How is it used today? What materials may letters be made in? We teach by asking questions; we learn by trying to find the answers.

Today lettering is regarded as a good exercise in creative design; it is an exercise in drawing; it is a good training for the eye and hand. More than that, it is fun.

Letters can be made in any material, not only with the orthodox pencil, pen and brush on paper—but they may be cut out of wood, modelled in plasticine, made out of buttons, nails, wire, chocolate, vegetables, flowers, pastry, soap—indeed anything that can be persuaded to take on the shape of letter forms.

In order to shape letters well we must understand them, and in order to understand them we must make them. But too much intellectualisation can inhibit creativity. Learn by doing, and when you have learned—go on doing. During what we might call apprenticeship, the method of working, the thinking process is more important that the finished job.

Good lettering is clean, sharp, crisp, exact and yet at the same time free. These may seem to be almost contradictory qualities. Striving too hard for cleanness and exactitude is apt to result in dull, stilted work without vitality. The earnest endeavour to be free and spontaneous may seem to some people to be sloppy and indisciplined. To achieve freedom with precision requires hard work and practice.

Some dull laboured work is inevitable in the course of attaining an acceptable standard of accuracy. The musician must practice (perhaps painfully) in private in order that his playing may appear spontaneous in public. The sportsman must stretch his muscles to the limit during training so that he is prepared to meet the stresses of competition.

With increased familiarity with the detail of shapes of letters, and with the absorption of knowledge about legibility and the historical background of our alphabet, freedom and spontaneity will come. You can only be spontaneous within the knowledge and skill you have. You can only acquire knowledge and skill by study and practice.

Tracing is a good way of getting to know the shapes of letters particularly as a supplement to free-hand drawing and writing.

Probably the best paper for this purpose is a medium weight Bond or Bank. This is transparent enough to see through to the shapes of letters and firm enough to take pencil, pen or brush. Tracing is not a kind of 'cheating' or a way of obtaining seemingly well proportioned letters quickly and without much trouble. To be of any benefit tracing should be done carefully, thoughtfully, critically. The contours should be followed precisely, and you will discover refinements of form which would almost certainly escape you by looking only. Keep your pencil sharp in order to create crisp contours, and try to judge the right tone of letter. Trace whole alphabets of caps, lower case and italic. It can be very rewarding.

As is said elsewhere in this book, spacing and placing influence the effectiveness, or otherwise, of letters; so practice placing words appropriately within a given area and with the correct amount of space between the letters. Rule faint guide lines on the Bond paper in the position you judge to be

correct. The base-line alone is often sufficient, but the beginner will probably find it reassuring to rule a cap-line too, and if lower case is included, a mean-line also. Lay the paper over the lettering specimen, tracing each letter in turn. By moving the paper to the left or right before you trace each succeeding letter you put more (or less) space between the letters. By moving the paper up or down, you increase or decrease the space between lines.

Optima is a good letter to begin with. It has no serifs, but there is an elegant 'waist' in the stems. Perpetua or Caslon or Garamond are good practice with a serifed letter.

It is a good discipline to trace a classical serifed letter and then, in turn, one of the major families of letter-forms, e.g. a sans serif, a slab-serif, a modern face, a copperplate and so on.

For practical reasons we are here concerned mainly with making letters with the pencil, pen or brush on paper as being the most convenient tools which everybody is likely to have.

At first, the making of letters should be practiced, not as an end in itself but as a means of understanding letters—what they are, what they can do, what can be done with them. It does not matter if the first few exercises are not works of art. What does matter is how well you are understanding what you are doing. You cannot hope to do anything well unless you know what you are doing.

One of the most fundamental qualities of a good script, whether it is in the Latin, the Cyrillic, the Arabic or the Hebrew alphabet, or whether it is in a non-alphabetic script like Chinese or Japanese—is rhythm. The common characteristic of all good scripts is rhythm. Closely allied to rhythm is texture, indeed a pleasant texture is one of the products of a good rhythm.

As we said earlier, the Latin alphabet is largely composed of straight lines, most of them vertical so that the basic rhythm is that of the verticals. These should come at satisfying intervals like the beat of music. And, like in music, the beat or interval need not necessarily be mechanically exact but regular enough to give unity and coherance.

Good lettering depends not only on good individual letters, but on their harmonious relationships. The relation of one letter to another, and the association into words and lines is crucial. As one is drawing a letter one is constantly adjusting it in relation to its immediate neighbour, and running ones eye along the line to make sure it is in harmony with all the other letters.

It is not enough to know and to be able to draw adequately all the letters of the alphabet or even to be able to group the letters into words and lines; such letters and words must be arranged within a given area be it a page, a memorial stone or a shop front. This involves a choice of size of letter, weight, placing and general character in relation to its purpose and the intended environment.

Words are uttered in different ways on different occasions, varying in tone from a whisper to a shout. The tones of voice can be roughly approximated by tones of letter, that is, by the weight resulting from the thickening of the strokes and thereby reducing the size of the counters. Be counter conscious. A right balance between the area of the strokes of the letter and the area of the counters is vital to legibility.

Three Ex Libris by Villu Toots.

49

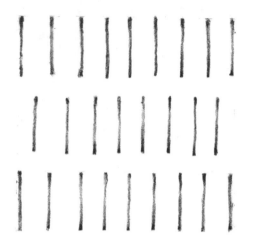

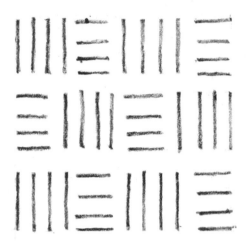

First practice the suggested exercise of filling a square with a succession of vertical lines made with a pencil, which has had its point rubbed down, to make a line almost the width of the lead. As neatness and a sense of spacing and placing are also important qualities to develop, take care with the guide lines, the margins and in the accurate trimming of the thin card on which the exercises are done. Make every card a uniform size. Keep the margins consistant and keep them clean. Get into the habit of measuring accurately so that the faint guide lines are horizontal and at precise intervals. Thick paper is an alternative to card and if that is not available use the Bond

paper recommended for tracing. Bond paper is often sold in blocks called layout pads.

When you make the vertical strokes press the pencil firmly at the beginning and at the end of each stroke which might be regarded as an incipient serif. This gives a kind of finality to the stroke, and by being repeated at short intervals in a horizontal line it adumbrates the imaginary cap line and base line.

Experiment with the space between strokes. If they are too close together the lines are hardly seen as separate strokes, but appear as a band of grey. If they are too far apart they

seem to have no relation with one another. There is a happy medium. There must also be a right proportion between the length of the stroke and its thickness.

After doing this exercise a few times make a pattern by alternating a series of verticals with a series of horizontals, it should help you develop a sense of pattern and texture.

But there are also curves which must be incorporated into the rhythm. Fill another square with a succession of verticals, some with horizontals attached, interspersed with curves. Do not be distracted by any chance resemblance to letters or words. Concentrate on acquiring a sense of rhythm.

Then incorporate diagonals into the sequence, once more trying to create a pleasant texture which may begin to look like lettering from a distance but without actually being composed of letters.

Try to 'write' the strokes. By that I mean make them spontaneously as though you were writing rather than deliberately drawing. Spontaneity is a vital quality of good writing and lettering and comes from practice.

51

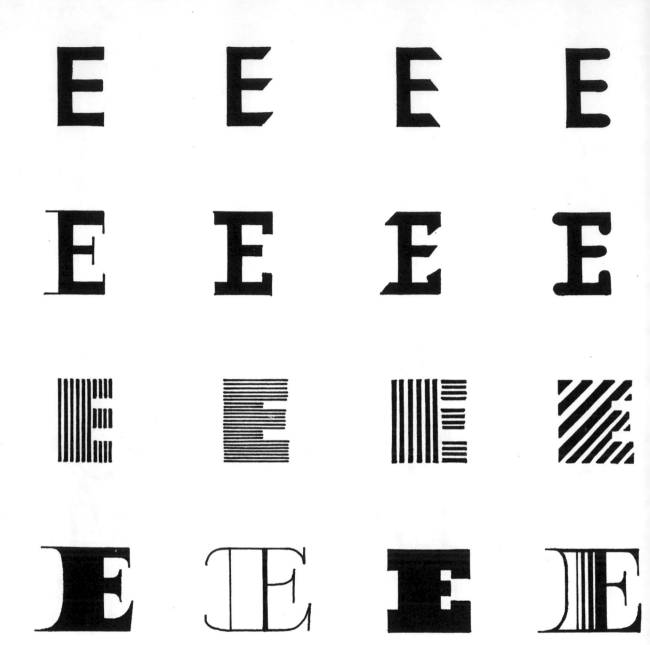

The personality of a letter is changed by sloping the ends of the strokes or by rounding them. Even sloping to the right or to the left makes a surprising difference.

Serifs, of course, are one of the most conspicuous features which can alter the nature and mood of a letter. Thickness and length are obvious differences, also the presence or absence of brackets.

The area of the letter may be formed by parallel lines and the feeling produced is different whether the lines are vertical, horizontal or diagonal or thick or thin.

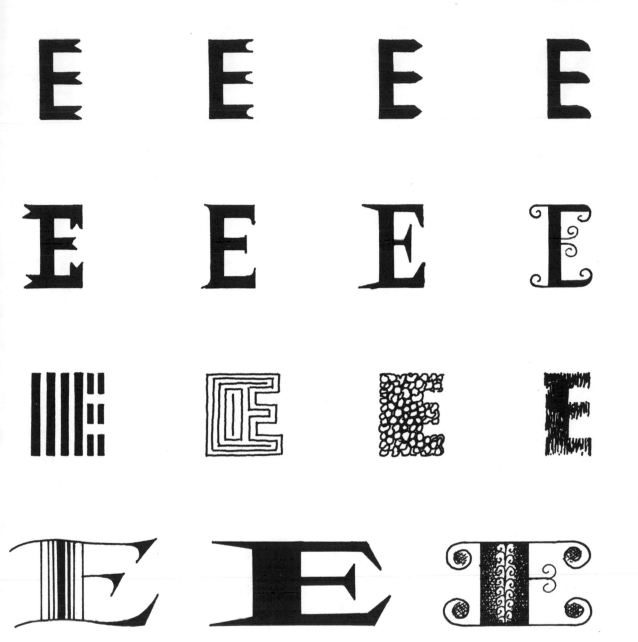

Indentations at the ends of strokes, whether triangular or semicircular also change the personality of a letter.

Serifs may be large, bracketed, triangular or only just perceptible. But even the tiniest serif affects the nature of a single letter, a word, a line, or a mass of letters.

If the normal shape of a letter is filled with tone a reasonable legibility is maintained whether the filling is neat and ruled or composed of a kind of scribble.

Take any letter you wish and distort it by adding to the form until its character has disappeared and the area is solid. Then gradually erode the solid until the letter appears again.

Make the letter thinner and thinner but without distortion.

Make the strokes thicker and thicker to the limit of legibility.

Make the letter narrower and narrower till barely legible.

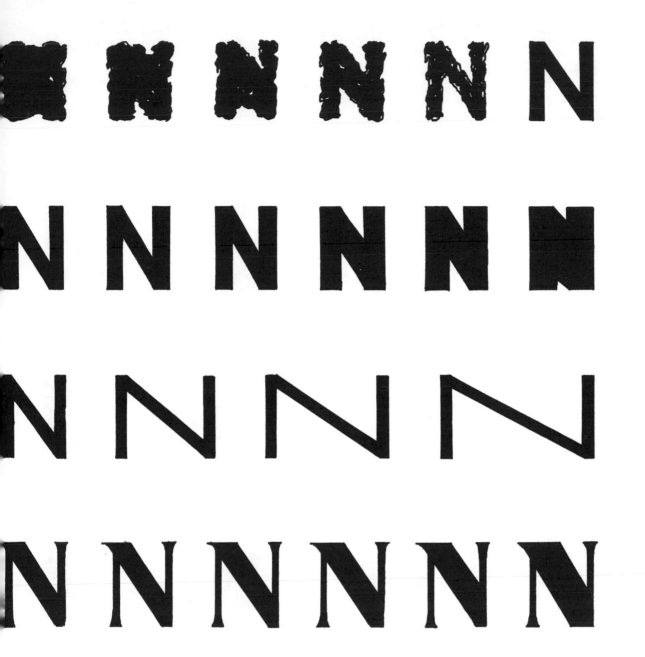

Make it wider and wider. Even the widest above may be legible under certain circumstances.

Try similar exercises using a letter with thick and thin strokes.

These exercises are to develop a sense of form, weight and texture, and to foster skill in finish and execution. They are not an end in themselves.

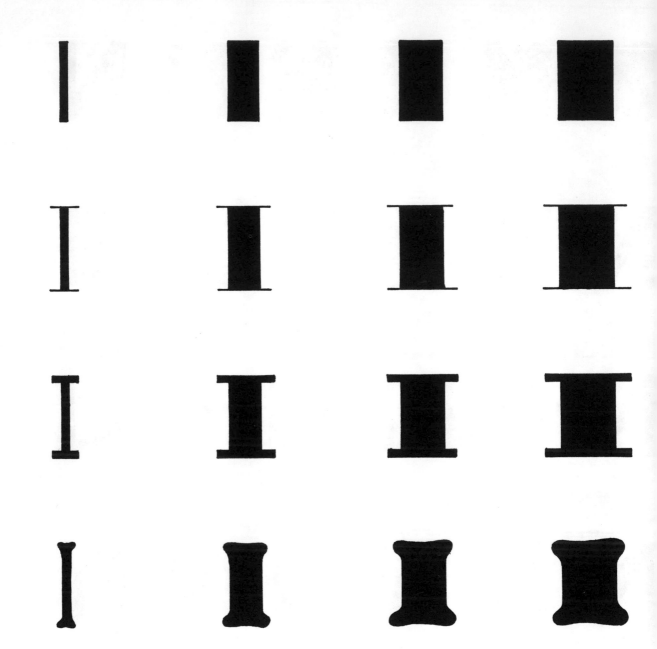

The letter I in a light weight of sans appears a simple line. There is a tendency for the eye to travel along a line. As a line is thickened the linear feeling disappears, the directional feeling is diminished and it becomes more of a surface than a line.

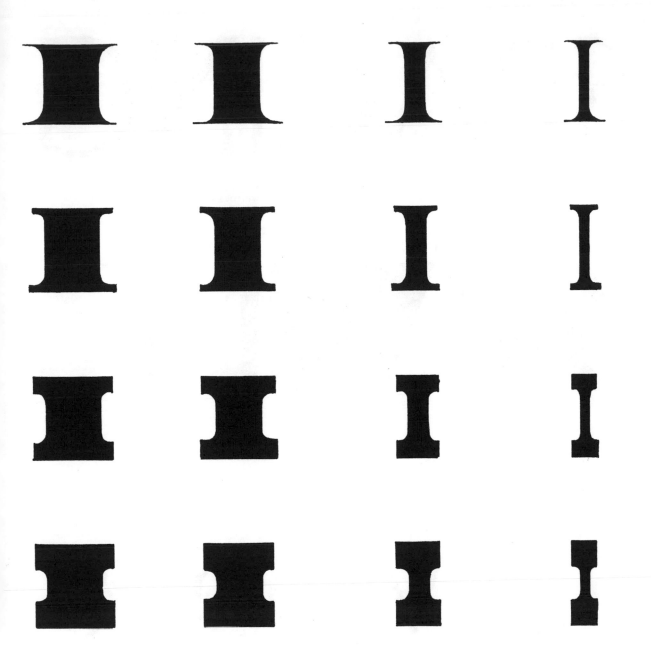

This is a good exercise in controlling the tone or weight of a letter. It also brings out the important influence the serif has on the character of a letter.

SPACING

When two vertical strokes come next to one another as they do in the word above, the letters I and N seem uncomfortably close. On the other hand PAC seem too wide apart.

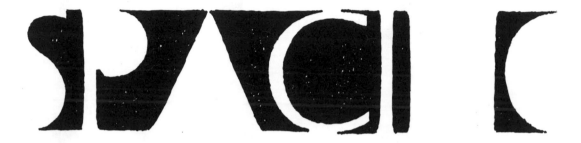

Here the spaces between the letters are detached to draw attention to the shape of the spaces. It also emphasises the way the counters of letters like C attach themselves to the spaces between the letters. Counters of letters like N, M, V, W, also tend to attach themselves to the space between lines. Below we see the difficulty when L is followed by A.

LAVENDER

Deliberate ambiguity runs through many of the arts today and it has become a vogue in the design of 'house marks' or logotypes for the letter and its background to appear to change place. It is certainly a good exercise for a student to experiment with the shapes of the counters of letters so that sometimes there appears to be a black shape on white and

sometimes a white shape on black.

The counters may be changed in shape while still remaining abstract, or they may be made into the shapes of other letters as in the above sketches. The letters might represent the initials of a firm or organisation and the result may be a useable logotype. But the object of the exercise is not

SPACING

Here the space between PAC has been reduced and increased between I and N to almost double.

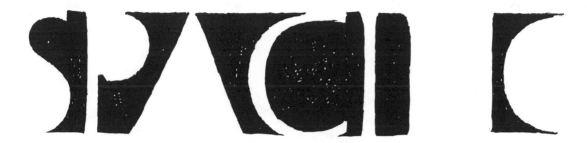

It will be observed that the space between I and N is here about double that on the opposite page. This diagram also demonstrates the importance of the shapes between letters. In this instance, the word is reasonably legible by the use of the spaces between letters only.

Below, more space is inserted between E, N, D, E, R, to even up the apparent large space where A and L come together.

LAVENDER

necessarily to produce a logo acceptable to a client. The aim is to train the eye to become sensitive to the great significance of counters and their relation to the letter as a whole.

It may also be used as an exercise in technique, in the manipulation of a ruling pen or a Rapidograph. It could be an exercise in clean finish and smart presentation. On the other hand it may be regarded as an exercise in thinking graphically but where the idea or conception is more important than the execution. Here the designs were drawn freely, indeed quite spontaneously without forethought or roughs, with a felt-tip pen.

See next page.

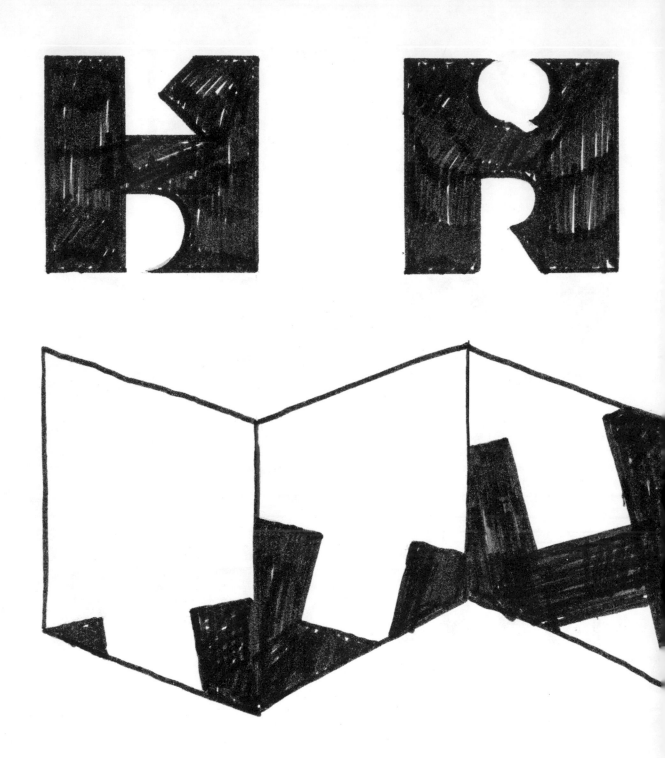

The lower design might be thought of as a folding 'book' that opens out concertina-wise. At one end of the sequence the whole page is almost white with only a small fraction of a letter on it. On each succeeding page more and more of the letter appears (at different angles) each page getting darker and darker until on the last page the letter almost fills the

area and is black nearly all over.

The alert student will discover many things. He will become aware of how much or how little of a letter is necessary for its identity to be apparent. He will discover what interesting shapes are created by parts of a letter, and how background shapes can be very surprising and very exciting.

60

The above diagram was drawn freely as a 'rough' with a felt tip pen. But it would be good practice for the student after making a succession of roughs to choose the best and develop it as a design, drawing it carefully on card.

This could be an exercise in precise drawing and design and in clean finish. Making the 'book' would also be good practice in cutting card really square and in devising hinges where the pages are connected to one another.

Any letter of the alphabet may be chosen for treatment and any style of letter. It is an exercise in discovery.

AVRELIO

AVG · LIB

APHRODISIO

PROC · AVG

A · RATIONIBVS

S · P · Q · L

DEDIC · Q · VARINIO · Q · F

MAEC · LAEVIANO · AED

Set in Goudy Old Style Capitals. How well Goudy has captured the spirit of Roman inscriptions.

The Roman Alphabet

An Analysis of the Norm

The main stream of lettering has run into typographic channels for the last four hundred years at least, and so in addition to the drawn or cut letters a number of typographic alphabets are set out for careful study.

Whatever the style of letter one may say that there are three basic 'alphabets': CAPITALS, lower-case and *italic*. Some letters, like I and O are more or less the same shape in caps, lower case or italic—O, o, *o*. But the shape of the cap A is quite different from the lower case and italic. The cap A is triangular and composed entirely of straight lines; the lower case a is a two-decker rounded form, and the italic is usually a single decker oval shape. In Optima type, in which this book is set, the italic is really a sloped Roman and is therefore not typical.

Eric Gill said 'letters *are* such and such forms; therefore, whatever tools and materials we have to use, we must make these forms as well as the tools and material will allow . . . The mind is the arbiter in letter forms, not the tool or material. This not to deny that tools and materials have had a great influence on letter forms. As the Roman, when he thought of lettering, thought of inscription letters, so the medieval man thought of written letters. Nevertheless, in no case does the scribe imagine he is inventing a new form; he is only concerned to make, well or ill the form with which he is familiar. So in the 20th century, when we write a letter carefully we call it "printing". The printed letter is lettering for us.'

That, of course, is not the whole story, but the moral is plain 'just as a man who knows his road can occasionally jump off it, whereas a man who does not know his road can only be on it by accident, so a good clear training in the making of normal letters will enable a man to indulge more efficiently in fancy and impudence'.

On this and the next sixteen pages the letters of the Latin alphabet are displayed in large sizes in order that the shapes can be studied in greater detail than is possible with smaller sizes. The first few letters are made really large so that the student may practice on this scale with black paper or thin card, cutting out each letter with scissors or scalpel. Manufacturers of types usually draw each letter about this size even though the final type might be as small as the one you are reading now.

If the letter is to be reduced considerably in size, the design must be modified to allow for the reduction. A good small letter is not simply a reduction of a large one nor is a satisfactory large letter a small one blown up. Ideally any letter should be designed in the size in which it will be read.

Letters cut out in card or thick paper can have their contours refined by the use of glass paper to shave down any bulges in the form. Try to get the precise proportion between thick and thin strokes. Take care at the junctions of strokes to avoid a dark spot. Serifs should appear to grow as naturally out of a stem as a bud grows out of the stem of a flower. It should not look as though a serif is a prefabricated accessory attached to a prefabricated stem. All the parts should flow easily into one another to make an integrated whole.

A brush is, of course, the most versatile of instruments and the student should learn to use the brush as soon as may be. The brush allows the finest of serifs to be made. It will produce a sumptuous swelling line from the finest hair line up to the width of the belly of the brush by increasing the pressure.

The letters in this section then, were cut from paper with scissors or scalpel, written with a pen or drawn with a brush. The remaining specimens for study, are printing types both traditional metal types and alphabets designed for photo setting systems.

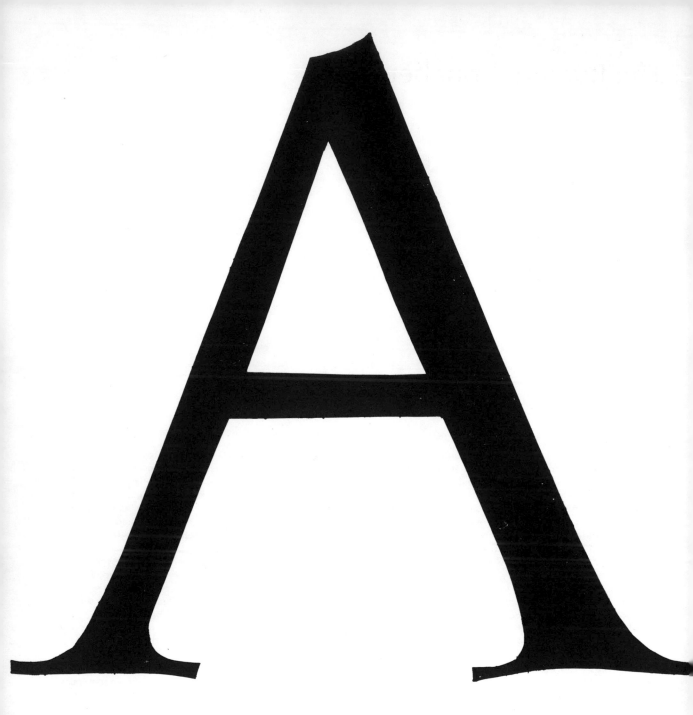

It is good practice to cut out large letters in black paper as the above letter was done. Cut letters inevitably have a crisp sharp contour not always easy for the tyro to achieve with a brush. By cutting out a letter it draws attention to the fact that a letter has both an inner and an outer contour. Both contours have to be drawn carefully whether made with a pencil, brush, scissors or scalpel.

On this page the pieces cut from the letter opposite are placed in isolation so that the shape can be studied carefully on its own. If these shapes or counters are well drawn they are usually interesting shapes in their own right apart from their relation to the rest of the letter.

65

All enclosed shapes are known as counters. The term comes
from the old craft of punch cutting. From the punches were
produced matrixes from which type was cast. The enclosed
shapes were made by a counter-punch which was driven
into the master-punch. The completed master-punch was
struck, that is, driven, into metal which became the matrix.
The shape of the counter needs careful consideration.

Here the counters cut from the letter opposite are displayed
for emphasis. It draws attention to the difference between
the upper and lower counter. A Cap B is to me, a particularly
interesting letter. It is only just over half as wide as it is high.
Wider than this it can look unpleasantly corpulent.

The counter of a capital C is very dominant—like a target. Although the shape is related to a circle it is not an exact segment of a circle and could not be made with a compass without hand-drawn modifications. The upper and lower arms are somewhat flattened. If we imagine a letter O made of metal and a segment removed, it is as though the two arms of the resulting 'horse shoe' have been slightly pulled apart. In some sans serif alphabets the two arms of the C almost

68

meet. This, at a short distance, resembles an O. This is clearly undesirable. Every letter should be clearly distinguished one from another in a given context (that is, of course, unless the occasion is ornamental). But the student should learn to do

plain legible letters before flying off into phantasy.

As the opening of the counter is so wide it tends to link up visually with the adjacent background so assuming the next letter begins with a vertical, the resulting counter is as above.

69

The letter S has two counters both of which attach themselves strongly to the background before and after the letter. The resulting shape will depend on which letter precedes and which follows the S. It is frequentiy followed by an H or N— both of which start with a vertical stroke.

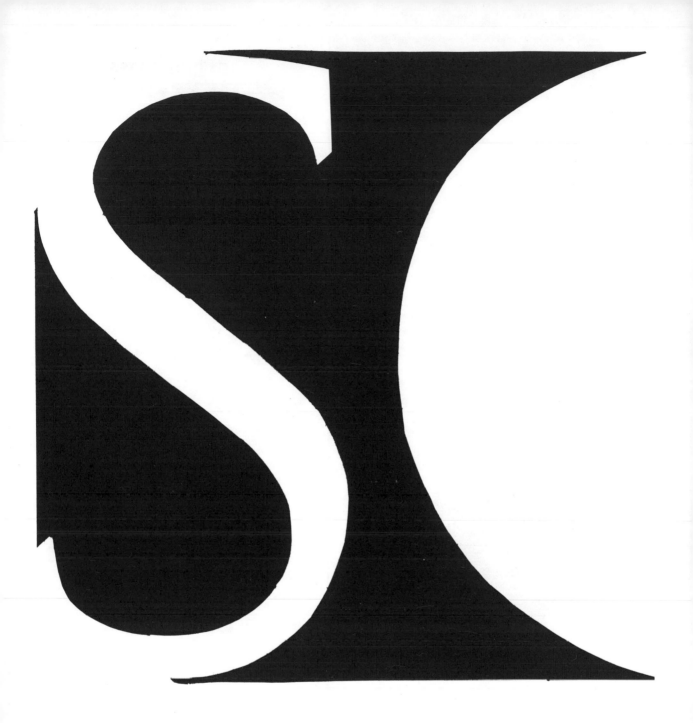

But it is often followed by an O or C which means that the right-hand boundary of the counter is approximately a semi-circle. Moving two letters further apart (or closer together) can alter the shape of the counter radically.

Letter D is traditionally a wide letter—about as wide as it is high. The counter is displayed detached from the letter which emphasises that where the arm of the bowl joins the main stem at the top there is an angle; at the bottom there is a curve or bracket. The point of maximum stress is above the middle which is in harmony with the O.

The classical proportion of E is about half a square. Many printing types have a cap E which is wider but the one on this page is a reasonable norm. Observe that the upper arm joins the stem at an angle, but the lower arm is attached to the stem with a curve or bracket. The terminal at the end of the lower arm differs from the upper one.

F is also a narrow letter and the arms usually meet the stem at about a right angle.

H, on the other hand, is a wide letter—as wide as it is high. The cross-bar is best placed just above the geometric centre.

G is a wide letter almost fitting a square. The vertical stroke varies in height, even in classical models. Sometimes it rises to half the height of the letter; sometimes it is very short with a little spur on the right as though the curve has gone through the stroke and is just sticking out on the right. The above example is a reasonable average.

There was no J in Roman times. It was devised later by adding a tail to an I.

73

K L

O P

K. Take care that where the tail joins the vertical it does not overlap the stem, otherwise the junction of three lines will appear as a dark patch. It is best for the strokes to meet at a point just touching the vertical. The tail and its terminal can be varied considerably.

Here the axis of the O is tilted. The point of maximum stress is slightly below the middle on the left and slightly above on the right. This angle is probably because in Roman times the letter was written with a flat brush rather like an edged pen and then cut into the stone; we continued to make a tilted O even when it was no longer 'written' with a broad brush.

L is virtually an E minus the upper arms. As with an E the arm is joined to the stem by a bracket. But there is no need for E, F and L to have precisely identical parts. They may differ subtly while remaining clearly close relations.

P is clearly related to R but the bowl is different. The bowl does not have the flatness at the bottom which is present in the R. Sometimes the curve of the bowl finishes at a point just touching the stem. Sometimes it does not quite reach the stem. Sometimes the curve begins to turn upwards just before it reaches the stem.

M is a beautiful rhythm of straight lines, but the angle of the strokes can vary. The strokes on the left and on the right may be vertical; or they can slope inwards slightly. The apexes at the top may be horizontal, or they may be pointed as in many Roman examples. Be careful where the strokes meet at the top to avoid a dark spot.

Q is like an O with a tail. The tail can vary in length and in the angle at which it projects. Sometimes the tail starts inside the bowl and swings to the right crossing the main curve.

N is capable of considerable variation in width while still remaining legible, but the classical norm is for N to be wide—almost a square. The thin strokes are usually vertical. It is

normal today for the junction of the vertical and the diagonal at the top to be horizontal. But the two strokes may meet at a point similar to the bottom. It was common in Roman times for the N to have a point at both ends of the diagonal.

R is an interesting letter and should be compared with P. But P is not necessarily an R without a tail nor is an R a P with a tail. The point where the bottom of the bowl and the top of the tail meet the vertical stem can vary in height. It is a matter of nice judgement to decide just where and how the tail springs away from the stem. In many classical examples the bowl is rather large and is connected to the stem by a short horizontal line. This means that the counter has a flat bottom.

S

T

W

X

S is a letter which is related to A, K, M, N, R, K, V, W, X, Y, in the sense that it has a diagonal accent that runs from top left to bottom right. This is derived from the edged pen which makes its thickest stroke when moved from top left to bottom right. Terminals may be sheared or barbed. About half as wide as it is high.

W is a letter the Romans did not have. It was not introduced until about the seventeenth century when printers were still using two Vs to signify W. Because V had the value of U it was a double U, just as we might have double O.

T is best if it occupies about two-thirds of a square. The ends of the arm may finish diagonally as in the above example or they may end with a vertical serif. It may even have a diagonal terminal on the left and a vertical one on the right as in Garamond type.

X is not always as easy to draw as it looks. The angle at which the strokes cross, and their relative thickness affects the four counters which must be carefully adjusted in relation to one another.

76

U normally has a thick stroke on the left and a thin one on the right—but it is not unusual for both verticals to be thick. Sometimes the right-hand stem follows through to the baseline and ends with a serif on the right as in Perpetua. There are three different cap U's in Perpetua.

Y is a letter with three strokes meeting at one point. It is necessary to avoid a dark patch at this point. It is also a matter of nice judgement at what height these lines meet. If it is too low the letter looks top heavy.

V is best kept reasonably wide, that is, about two-thirds of a square. The apex at the foot projects slightly below the base line in order to appear to rest on it.

Z is a reasonably wide letter. The terminal at the right hand of the bottom stroke is similar to that on the E and L. When designing an alphabet such similar features must be related but not necessarily identical.

abcd

jklmr

One of the first decisions to be made when designing a lower case alphabet is the x-height. How big are letters like a, c, m, n, o, etc., to be in relation to the caps? How long are ascenders and descenders to be? Will they be the same length or will the

efghi

nopq

ascenders be longer? An alphabet may have the descenders shortened without immediate loss of legibility but if ascenders are too short legibility suffers and the effect is ugly. Ascenders are usually slightly higher than the caps.

stuvw

123456

xyz&

7890?

A B
C M
T E

A double spread from Michael Harvey's booklet 'Letters into Words'. These are admirable letters. Mr Harvey considers them to be closer in feeling to printing types than to Roman inscriptions even though they are drawn with a brush.

83

Writing is a convention. The designer of letterforms interprets convention. He may try to peel out the nucleus of convention or to explore its edges, he has to stay within its limits; unconventional writing is no writing at all. Education in letterforms needs a clear concept of convention. The ideal situation is that of language. If languages had not their Websters and Dudens everybody would still try to express himself understandably (conventionally). In writing no convention exists that is generally accepted. Many teachers even contribute to the destruction of convention by advocating 'an individual hand'.

Even a modest attempt to describe convention will evoke contradiction.

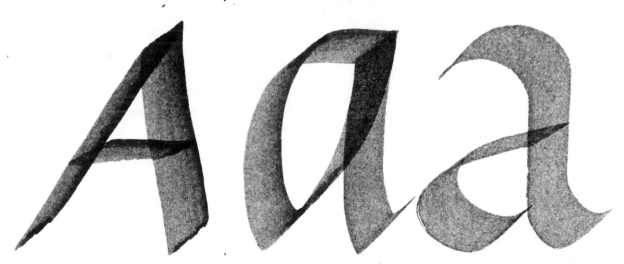

There is general agreement about each of these three signs being A, but any further specification has the character of a proposal.

Page from an essay written, in both senses of the word, by Gerrit Noordzij

84

ABCDE
FGHIJK
LMNOP
QRSTU
VWXYZ

Dorno Italic Capitals freely painted by Percy Smith, one of the best classical letterers working in England between the wars. He ran the Dorno Workshop which was a group of fine lettering craftsmen.

ABCDEFGHIJKLM
NOPQRSTUV
WXYZ&ÄÖ
1234567890
abcdefghijklmn
opqrstuvwxyz

OPTIMA designed by Hermann Zapf, 1958, Stempel.

This type, to my mind, is one of the best types of this century, indeed of any century so far. It is classical and serene yet essentially of the second half of the 20th century. The idea of Optima is based on a serifless roman. There are more serifless letters of the classical Roman and Greek period than many people realise who think of Roman lettering always as being Trajan or its derivatives. Hermann Zapf himself says that the design followed a visit to Italy where he was thrilled by unserifed letters in the Santa Croce in Florence. Originally thought of as a display type, before the designs were finished, he had turned it into a face that is not only effective in display but is equally useful in books on art, photography and technology, and is admirable for childrens books. This book is set in Optima.

The proportions are classical, the feeling is modern. There are thick and thin strokes in the traditional positions without making one think of the edged pen. Where an arch joins a stem the stroke is thinned otherwise the junction would appear too dark. The point of maximum stress is at a constant angle. The descenders are generous compared with so many sans serif letters. It is logical but not cold.

Zapf says he would have preferred to call it 'Neu Antiqua' which is logical and modest like the man, but Optima it is now called and is certainly one of the best letter-forms of this age on which a student may model his understanding of letters.

ABCDEFGHIJK
LMNOPQRS
TUVWXYZÆŒ
1234567890
abcdefghijklm
nopqrstuvwxyz

PERPETUA designed by Eric Gill, 1929, Monotype.

Thirty years and the Second World War separate Perpetua from Optima and, in a sense, these two type faces reflect the spirit of the age in which they were produced. They certainly reflect the spirit of informed opinion on letter-forms of their period and also the personalities of the designers.

Eric Gill became a practising Roman Catholic and his religion prompted the name he gave to the type—Perpetua. Perpetua was a female saint who was martyred at Carthage in A.D. 203 by being thrown to the leopards (not lions). Gill had also spent many years cutting inscriptions in stone using a classical roman form of letter but not without a touch of his own strong personality.

Perpetua shows some of this inscriptional quality. It also shows the influence of the Monotype Corporation. There is a considerable difference in thickness between the stems and the thin strokes in the larger sizes. The ascenders, and particularly the descenders, are longer than average which means that the letter seems small for its point size. The tail of the cap R swings away from the stem in a characteristic curve which George Friend, the engraver and punch-cutter, told me that Gill got from Caslon. Be that as it may—compare the cap R in Caslon 72pt with the cap R in Perpetua.

ABCDEFGM
HIJKLNOPS
QRTUVWX
YZ&:£abcdef
ghijklmnopqr
stuvwxyz

GARAMOND Monotype Series 156.

The type displayed here is Monotype Garamond series 156 which differs somewhat from the types called Garamond issued by other typefounders. It is not the intention to distinguish between the different founders' versions or to say which I think is best, but only to present this as an admirable example of the family of Garamonds.

Claude Garamond after whom the type is named, was a distinguished French designer and punch-cutter who died in 1561. It is possible that Garamond was the first to treat roman and italic as constituents of one fount. He based his design of the roman on Aldine Poliphilus, and his italic on a letter of Arrighi.

The history of the form of letter we now call Garamond is complicated and irrelevant to our purpose which is to recognise it as a landmark in the development of old style types and one of the best of its kind.

It has lengthy ascenders and descenders; a high cross bar to cap A; the curve of the bowl of P does not join the stem; the right-hand serif of T is vertical while the one on the left is diagonal (both are diagonal in some versions); the middle strokes of W cross one another. In the lower-case the serifs at the head of i, j, m, n, r are cupped (but not in some versions where the serif is triangular).

A B C D E F
G H I K L M
N O P Q R S
a b c d e f g h i j k l
m n o p q r s t u v
w x y z æ

CASLON OLD FACE designed by William Caslon about 1734. Stephenson, Blake.

Caslon Old Face was one of the best book types for almost two hundred years and its larger sizes may still be seen in magazine advertisements. It was cut by William Caslon in the few years preceding 1734 when the first specimen sheet was published. William Caslon was an engraver of gun barrels who also cut letters for book-binders. Printers directed his attention to type-founding. But his first type was an Arabic cut in 1720.

Until Caslon launched his Old Face the best types available in England were Dutch, and there is little doubt that Caslon modelled his letter on the best Dutch types of the 17th century. It is a fundamentally fine letter, and though from time to time it may have gone out of fashion, it has never gone out of use.

The cap A has a sheared slightly cupped apex; the C has a faintly barbed beak in both upper and lower arms; the E is wider than the classical half-square. But in general its goodness lies largely in its neutrality, its lack of eccentricities. The 72pt size is to me, particularly beautiful. All the sizes are not equally good.

ABCDEFGHIJK
LMNOPQRS
TUVWXYZ
1234567890
abcdefghijklm
nopqrstuvwxyz

UNIVERS designed by Adrian Frutiger, 1956–8, Deberny and Peignot.

Any type face which proves popular is likely to be followed by a series of different weights and variants. Usually these are designed over a number of years and sometimes even by different people so that there is no logical or aesthetic coherance in the range. Univers was different. There are twenty-one different series within the Univers family and for the first time in history, the whole range was conceived as a logically related scale of tones and sizes.

Adrian Frütiger, the designer, is a Swiss who says he 'was blessed first with an artistic feeling for shapes, and second with an easy grasp of technical processes and of mathematics'. A rare combination of talents. Though he had dreams of becoming a painter, he was persuaded to learn about printing and specialise in lettering. The latter he studied at the School of Arts and Crafts in Zurich.

While he was still a student there he drew a series of three grotesque (sans) faces—normal, semi-bold and bold. Many years later, after working on a Garamont, Baskerville and Bodoni, a sans was required and his student designs became the starting point from which Univers developed.

It has proved a great success and as will be seen elsewhere in this book the principle behind Univers has been applied to Hebrew and Japanese. Success indeed.

Compare Univers letter for letter with Helvetica.

ABCDEFGHIJK
LMNOPQRS
TUVWXYZ
1234567890
abcdefghijklm
nopqrstuvwxyz

HELVETICA designed by Max Miedinger 1957, Haas.

There is a clean clinical purity about Helvetica that some people think is typically Swiss. It was designed by Max Miedinger who was apprenticed as a compositor and developed into a typographic designer. He, like Frütiger, studied at the School of Arts and Crafts in Zurich, with its tradition of perfectionism in letter-forms. After working as a designer in advertising he became a representative of the Haas Typefoundry which is one of the oldest foundries in the world.

He says selling type to hundreds of printers taught him so much about good and bad types that he decided to create a typeface of his own and this is what happened, he assures me.

He left Haas to set up a studio of his own but kept in touch with the firm and designed Pro Arte, a French-antique letter resembling 'Playbill'. This was followed by a sans serif letter which at first was called New Haas Grotesque. It became a world success. It came on the market when sans serifs were in the ascendant, but there is no doubt in my mind that this letter is one of the best sans serif faces ever designed. Some people find Helvetica warmer, more colourful and less calculated than Univers, but it was the result of much trial and error over a long period before all the characters were brought into such a close harmony. There is now a wide range of weights and treatments such as Outline, Shaded, Extended and Compressed.

26 GOOD REASONS TO USE NEON

Tiffany Medium

There have been many designs of letters simulating neon tubes, but perhaps the best available for general use in printing is ITC Neon. It is surprisingly legible and has an interesting texture.

ITC Tiffany was designed by Ed Benguiat based on two late 19th century type faces Ronaldson and Caxton. It has colour and atmosphere (like so many types issued by the International Typeface Corporation) which is so appropriate for advertising literature. It has one or two irritating eccentricities —but a useful letter for all that.

26
good
reasons to
use
AVANT®
GARDE
GOTHIC
BOOK

This alphabet and its variants grew out of a design by Herb Lubalin for a logo for Avant Garde Magazine in New York about 1968. Unusual features were the strange ligatures and unorthodox A and V. In spite of diminished legibility it was very successful and it led Herb Lubalin and his associates at The International Type Face Corporation (ITC) to go on and design the entire alphabet. Tom Carnasse worked out many of the ligatures and spent months of drawing and redrawing under the expert eye of Herb Lubalin and Aaron Burns and finally produced Avant Garde in five weights and condensed. Type designs are often co-operative efforts in which many people play a useful part. Avant Garde has made its mark, and all over America and Europe one may meet the occasional influence of Avant Garde ligatures.

93

ABCDEFGHI
JKLMNOPQ
RSTUVWXY
abcdefghijkm
nopqrstuvwyz
1234567890

BODONI Monotype Series 135.

The name of this type is that of Giovanni Battista Bodoni of Parma, Italy, who was one of the most famous printers of the late 18th century. But he was far from being the first to introduce the features that distinguish what came to be known as 'modern' face. There had been a tendency to admire the sharp hair-line serifs and smart curves of copperplate engraving for some time and it was natural that typefounders would produce types in this style. A. F. Johnson said 'the evolution from old style to modern face is largely a question of technique, rather than the rejection of one design for another on a definite principle'.

I have in my possession a copy of the works of Horace published by John Pine in 1733 in which every page is en-

graved with astonishing virtuosity, on a separate copperplate. The text letter has an x-height of about 1.55 mm. The printing and registering of these copperplates is in itself a tour de force and the effect is brilliant. It is small wonder that letterpress printers should also try to rival such productions.

Baskerville types were a transitional stage between oldface and modern, but it was Didot and Bodoni who really established modern face. After Bodoni died, his Manuale Tipografico was published in 1818 and is 'the most sumptuous display of modern face types in existence'. The type you see on this page is a version cut by the Monotype Corporation in 1921. Virtually all typefounders or producers of alphabets for other printing systems have their own version of Bodoni.

ABCDEFGHIJKLMNOPQRSTUVWXYZ

.,:;-'?!«»()&£C

1234567890

BIFUR designed by A. Cassandre, 1929, Deberny and Peignot.

This witty alphabet was designed by the great French Poster Designer. It is reminiscent of some of the work of the Russian artists Favorski and Chekhonin in the early twenties.

Only useable for one or two words at a time but worthy of study for the shrewd emphasis on the significant parts of each letter. Compare with Brian Coe's alphabet on page 42.

ѿ МАТѲЕАС СТОЕ БГЛБЕ СОБРАНIЕ

КНИГА РОДСТВА IСХВА СНА ГЛА
ДВДВА , СНА АВРААМЛА · А
АВРААМЪ РОДИ IСААКА · IСАА
КЖЕ , РОДИ IIАКШВА · IIАКШ
ВЖЕ РОДИ , IIДѪ ИБРАТIЮ
ЕГО · IIДАЖЕРОДИ , ФАРЕСА IIЗАРА
ѿДАМАРЫ · ФАРЕСЖЕ РОДИ , ЕСРШ
МА · ЕСРШМЖЕ РОДИ , АРАМА · АРА
МЖЕ РОДИ АМIНАДАВА · АМIНАДА
ВЖЕ РОДИ , НААССШНА · НААССШ
НЖЕ РОДИ , САЛМШНА · САЛМШНЖЕ
МЕ ПРЕЖ ТВО ХВЫМЪ СТЫ ѿЦЪ ·

Non-Latin Scripts

Cyrillic
Arabic
Hebrew
Chinese & Japanese

The study of non-Latin scripts is justified on many grounds. The economy of East and West is becoming so interrelated and inter-dependant that the actions of one country or group of countries can rapidly affect the prosperity of others. Business relations demand a knowledge of each others language and, of course, a knowledge of the appropriate script. In practice, this means that informative literature concerned with a manufacturer's goods needs to be in the language and script of the country for whom the goods are intended. This is usually accompanied by persuasive advertising in the relevant scripts. This in turn makes it necessary for manufacturers, or their advertising agents, to employ people with some knowledge of, or at least, interest in the foreign scripts, to work on the design of these publications. The author has had such experience.

Another justification of the study is the increasing cultural relationship with countries that used to be thought of as too remote, in spite of different religious or political systems. In the arts there have long been cultural exchanges, particularly in music and the visual arts. We are now willing to accept different artistic forms whether they are Negro Sculpture, Indian Music, Chinese Painting, Russian Ballet or Japanese Colour Prints; and now Islamic splendour is being displayed in the West as never before.

Calligraphy and letter-forms in general play a very important part in the cultures of Islam and China and I believe we should give more time and thought to an understanding of different forms of writing and lettering.

As I hope the examples shown on these few pages will demonstrate, related alphabets and non-alphabetic scripts have many things in common, not the least being beauty. At their best, all alphabets and writing systems might be regarded as works of art or craftsmanship, as well as vehicles of communication. We can enjoy these examples of lettering type or calligraphy in Cyrillic, Arabic, Hebrew, Chinese or Japanese as things of beauty in their own right whether we understand the language or not. We will recognise how much Cyrillic has in common with the Latin and Greek alphabets. We will discover that the names of the first three letters of the alphabet in Latin, Greek, Cyrillic, Arabic and Hebrew are

almost the same. This is evidence of a common heritage no matter how different the letter-forms may be today.

In Cyrillic, twelve of the characters are exactly the same as Latin, though some are pronounced differently; some of the characters are the same as Greek or are derived directly from Greek. Cyrillic has a much more noticeable affinity to Greek than Latin has. But that all three are related is very evident.

What may seem surprising is that Hebrew and Arabic, like Greek, Latin and Cyrillic are all derived from the same North Semitic Alphabet. Hebrew and Arabic both retain such a strong flavour of the pen, that it is easy to see they are related. Both have been strongly influenced by religion to retain their original forms. It is more difficult to see the relationship of Hebrew and Arabic to Latin, Greek and Cyrillic. It is not within the scope of this book to show all the intermediate stages of development, but some time spent in the Alphabet Room at the British Museum should make the gradual transformation from the North Semitic script into the others mentioned in the diagram on page 30 quite apparent.

The changes in form come about not only by being adapted to different languages in different regions with different cultural traditions, but by the different writing materials used. A reed pen lends itself to thick horizontals which we see in Square Hebrew and Arabic. But the standard of most scripts derives from elegant stone inscriptions.

It appears that until the time of Muhammad the Arabs had little use for writing—their poets preferred to hand down their compositions by word of mouth, employing youths specially for this purpose. They are not the only example in the ancient world of a 'highly language-conscious and poetically gifted people who were mostly illiterate'.

Ever since Muhammad (about A.D. 570–632) some of the most magnificent manuscripts of all time have been produced in the Arabic alphabet.

I hope that these few examples of unfamiliar scripts will at the very least, give pleasure in their contemplation, will bring satisfaction in an increased knowledge of their nature and will perhaps inspire some to attempt the practice of one or more of them, and return to the latin alphabet with a refreshed eye better able to render our familiar letter-forms.

GREEK 24 letters	CYRILLIC 33 letters	LATIN 26 letters	HEBREW 22 letters	ARABIC 28 letters
Α α alpha	А а ah	A a a	א aleph	ا ali
Β β beta	Б б beh	B b b	ב beth	ب b
Γ γ gamma	В в veh	C c c	ג gimel	ت t
Δ δ delta	Г г geh	D d d	ד daleth	ث th
Ε ε epsilon	Д д deh	E e e	ה he	ج jī
Ζ ζ zeta	Е е eh	F f f	ו van	ح hā
Η η eta	Ё ё yo	G g g	ז zayin	خ kh
Θ θ theta	Ж ж zheh	H h h	ח cheth	د dā
Ι ι iota	З з zeh	I i i	ט teth	ذ dh
Κ κ kappa	И и ee	J j j	י yod	ر rā
Λ λ lambda	Й й e kratkoe	K k k	כ kaph	ز zā
Μ μ mu	К к kah	L l l	ל lamed	س sīn
Ν ν nu	Л л el	M m n	מ mem	ش shī
Ξ ξ xi	М м em	N n n	נ nun	ص sā
Ο ο omicron	Н н en	O o o	ס samekh	ض dā
Π π pi	О о o	P p p	ע ayin	ط tā
Ρ ρ rha	П п peh	Q q q	פ pe	ظ zā

GREEK	CYRILLIC	LATIN	HEBREW	ARABIC
Σς sigma	Рр er	Rr r	tsade	ع 'ain
Ττ tau	Сс ess	Ss s	goph	غ ghain
Υυ epsilon	Тm teh	Tt t	resh	ف fā
Φφ phi	Уy oo	Uu u	shin	ق kāf
Χχ chi	Фφ ef	Vv v	tau	ك kāf
Ψψ psi	Хх kha	Ww w		ل lām
Ωω omega	Цц tseh	Xx x		م mīm
	Чч cheh	Yy y		ن nūn
	Шш shah	Zz z		ه hā
	Щщ shchah			و waw
	Ъъ tverdi znak			ى ya
	Ыы yeri			
	Ьь myarki znak			
	Ээ eh			
	Юю yoo			
	Яя yah			

Independant	Final	Medial	Initial
ا alif	ا		ب
ب ba	ب	�	ن
ت tā	ت	ﺨ	ﺗ
ث thā	ﺞ	ﺨ	ﺛ
ج jīm	ﺞ	ﺨ	ﺟ

Normal variants of the first five letters of the Arabic
alphabet. Every letter has either two or four variants.

Glagolitic	Cyrillic	transl.	Glagolitic	Cyrillic	transl.
Ⰰ	Аа	a	Ⱇ	Фф	f
Ⰱ	Бб	b	Ⱒ	Хх,х	kh
Ⰲ	Вв	v	Ⱁ	Ѡѡ	o
Ⰳ	Гг	g	Ⱋ	Щщ	shch
Ⰴ	Дд	d	Ⱌ	Цц	ts
Ⰵ	Єє	e	Ⱍ	Чч	ch
Ⰶ	Жж	zh	Ⱎ	Шш	sh
Ⰷ	Ѕѕ,Ꙃꙃ	dz	Ⱏ	Ъъ	e
Ⰸ	Зз	z	Ⱐ	Ьь	i
Ⰹ	Ии	i	Ⱑ	Ѣѣ	e
Ⰺ	Іі,ї	i	Ⱓ	Юю	yu
Ⱂⱃ	ħ	dy		Ꙗ	ya
Ⰽ	Кк	k		Ѥѥ,ю	ye
Ⰾ	Лл	l		Ѧ,ѧ	e
Ⰿ	Мм	m		Ꙗ	ye
Ⱀ	Нн	n		Ѫж	o
Ⱁ	Оо	o		Ѭж	yo
Ⱂ	Пп	p		Ѯѯ	ks
Ⱃ	Рр	r		Ѱѱ	ps
Ⱄ	Сс	s		Ѳѳ	th
Ⱅ	Тт	t		Ѵѵ	i
Ⱆ	Ꙋꙋ,ү	u			

Glagolitic, Monotype Series 598 compared with Old Church Slavonic and a transliteration.

Ustav writing from the *Ostramirova Evangeli* (Gospels) 1056–7. The earliest dated Cyrillic manuscript. In the Leningrad Public Library.

Poluustav writing which succeeded ustav and became the model on which the first Cyrillic types were based. From the XIVth century onwards.

Vyaz, 15th century. Note the presence of curves which almost disappeared in the 19th century.

Vyaz, 19th century.

Cyrillic

A short account of the development of the Cyrillic alphabet
and its use in printing.

The Cyrillic alphabet is used for the Russian language. It is the 'first' language for most but not all the people in the fifteen republics which comprise the Union of Soviet Socialist Republics. Russian is the second language for the millions of others who speak as their native tongue one of the hundred other languages spoken in the USSR. In the Soviet region of Mongolia the language is written in Cyrillic characters, in the Chinese part of Mongolia it is written in Chinese characters. Cyrillic is the alphabet used for Bulgarian and some of the Yugoslav languages such as Macedonian and Montenegran.

To explain why the alphabet is called Cyrillic we must refer to another alphabet, the Glagolitic, which was used as long ago as the 10th century. The earliest surviving examples of Glagolitic writing are in Kiev, dated between A.D. 989 and 1000. Glagolitic survives today on the North Dalmatian coast.

In spite of controversy, it is now generally thought that Glagolitic was developed in the 9th century by the Slav Apostles Methodius and Constantine who became known as St Cyril. Later, St Cyril's name became attached to the Cyrillic alphabet which was used concurrently with Glagolitic. Mrs Granström of the Public Library in Leningrad, an expert on Glagolitic, thinks Glagolitic is related to astrological symbols. In the 10th, 11th and 12th centuries Glagolitic was rather rounded in form whereas in the 13th and 14th centuries there was a greater number of verticals.

The word Glagolitic literally means 'words for speaking'. This supports the theory also put forward independently in England, that early manuscripts were read aloud, and that the letters of the alphabet brought 'not a visual but an auditory memory'. In medieval times, most learning was acquired through the ear rather than through the eye. Today, in spite of radio, tape recordings, etc., most of our information is obtained through silent reading, that is, through the eye.

Though St Cyril's name has become attached to the alphabet it is questionable whether he can be said to have invented it. Cyrillic is a logical development of Greek uncials and of Greek ustav of the 9th and 10th centuries, indeed, the Greek ancestry is perhaps more obvious in Cyrillic than in the Latin alphabet. Modifications are to be expected as an alphabet is adapted to different languages as the Latin alphabet has been modified by the addition of extra characters in German, Swedish, Polish and many other languages. The Greek Orthodox church took the alphabet with it from Byzantium northwards through what we now know as Bulgaria, Romania and Moldavia into Russia.

The Cyrillic alphabet spread westward into Macedonia and Yugoslavia and north west through Czechoslovakia into Poland, where the first Cyrillic type was printed in Crakov in 1491, by Feol.

The earliest dated manuscript in Cyrillic is the *Ostromirova Evangeli* written between 1056 and 1057. The facts are clearly recorded in the colophon where the scribe Grigori explains that he wrote it for Ostromir, one time Governor of Novgorod, and calls on the Apostles to bless Ostromir, his wife and children and the friends of their children. Grigori concluded by begging the reader not to condemn him if mistakes are found—but to correct them, and give honour. As St Paul says —Bless but not blame.

This magnificent manuscript is written in USTAV which is in the direct line of descent from Greek uncials. Whereas in the West, uncials grew into half uncials and then into minuscules which served not only religious but literary and scientific ends. In the hands of the Orthodox church, the uncial was used almost exclusively for religious and liturgical texts. As the Orthodox church emanated from Byzantium the feeling of most early Russian art and manuscripts was Byzantine. Byzantine feeling can be detected in Russia, even today, just as we have Greek and Roman influences lingering on throughout Europe.

The ustav of the *Ostromirova Evangeli* is a dignified cere-monial letter that is still much admired by Russian letterers. To our eyes, trained to admire close spacing, all the letters appear far apart from one another. Nevertheless, a rich over-all texture to the page is achieved.

It was not a rapidly written letter—on the contrary—a close examination of many pages reveals a thin space down the middle of the stems, suggesting, indeed one may say proving, that at least some of it was written with a narrow pen, taking two strokes for the stems. Certainly, on the pages I examined closely, the stems could not have been made with

a single stroke. It explains the M and A which would virtually have been impossible to write with a broad pen.

Ustav was the prime book hand until the 14th century when more ascenders and descenders occurred, letters were written a little more closely together and a style of writing was established known as Polu-ustav. Polu means half, so Polu ustav means half ustav. It is a terminology similar to our own uncial and half uncial, but the style is different, and polu-ustav did not undergo a change such as occurred when half uncial was transformed into minuscule in western Europe.

Poluustav was the normal book hand when printing was introduced into the Slav countries and so all the early type-faces were modelled on poluustav forms. Poluustav remained the standard letter until the reforms of Peter the Great at the beginning of the 18th century. Poluustav still had a Greek Byzantine feeling about it. The scribes frequently used contractions and placed diacritical marks above letters to indicate the omissions as was common practice through-out Europe.

Just as Gutenberg and other early printers imitated the scribes hand-writing and general format of the page current at that time and place, so the early printers in the Cyrillic alphabet produced books which had the same general appearance as manuscript books. The diacritical marks were copied, which must have been a compositor's nightmare. Headings and initial letters and other decorative elements also reflected the style of the miniature painters and rubricators of the manuscript books of the period.

The first book to be printed in the Cyrillic alphabet was in the Ukrainian language. It was printed in 1491 by S. Fiol who

number of curves. Local variants of Vyaz grew up so that there are recognisable Moscow, Novgorod and Pskov styles. In the succeeding centuries, the letters became more and more condensed (elongated) until, in the 19th century curves almost disappeared. Vyaz is a rich and decorative letter that can still be seen in Russia used for special purposes just as we use Uncials, Black letter or Versals when we think it appropriate for an occasion. It is sometimes elaborately ornamented with acanthus-like forms and formalised flowers, but Vyaz is really decorative enough in itself.

We have already said that poluustav was the normal bookhand of the 15th and 16th centuries. Just as in Italy, France and elsewhere, the scribes were not immediately made redundant by the invention of printing from moveable type but produced some of their most magnificent volumes after the invention, so, in Russia some of the finest manuscript books are of the 15th and 16th centuries. One of the greatest to my mind, is the superb *Beryova Evangeli* of 1531 in the Lenin Library, Moscow, where there is also the *Koshki Evangeli*, also supremely beautiful.

As the need for formal book hands declined other swifter forms of writing developed which are called SKOROPEECE (cursive).

Ever since Fyodorov there has been a succession of azbooki, a kind of ABC or instruction book for teaching children to read. They are of interest to anyone studying letter-forms because they show what in each age was considered the correct form of letters to teach to children. A particularly interesting *bookvar* (another word for an ABC primer) is that published by Karion Istomin in 1694. It is a

Evolution of lower-case t from the Greek and Roman cap T.

Evolution of the Cyrillic cursive t from the same Greek T.

was a German, in Crakow, Poland. It was another sixty years before a printing press was set up in Moscow. The earliest book known to be printed in Moscow is a Gospel of 1553–5, by an anonymous printer. There are six editions of books, using four different type faces by anonymous printers before Fyodorov who is the printer honoured by a statue in Moscow near the site of his printing press. Fyodorov is looked upon in Russia as the Founding Father of Printing rather as we look upon Caxton in England.

His first book was an *Apostol* (The Gospels) begun in 1563 and finished in 1564. He continued to print in Moscow but later continued in Lvov and Ostrog. The text-types were, of course, poluustav (no ustav types were cast). The headings and initial letters were wood cuts. The ornament on the head pieces is usually a form of acanthus, though some of the initials are reminiscent of a more purely Russian tradition.

In the illustration on page 96 under the head piece is a line of elongated letters which in the original is printed in red. The style of lettering is known as Vyaz. This had a Byzantine origin and became common in Russian books from the 14th century. As with the illustration on page 100, the earlier versions of Vyaz are not so condensed and still retain a

largish book 23.5 x 36.5 cm with copperplate illustrations. A whole page is devoted to each letter of the alphabet which is given in a variety of styles—Slavonic, Ustav, Poluustav and Skoropeece. Words beginning with the letter are used in a doggerel verse at the bottom of the page. The top two-thirds of each page is devoted to the variants of the letter together with illustrations.

During the 17th century some of these Azbooki or Bookvari were on scrolls. One I studied is about 30.5 cm wide and about 1.5–1.8 m long. It was more of a tour de force, a calligraphers pyrotechnic display, an object d'art rather than a tool for teaching youngsters to read. But a joy to any lover of lettering!

Poluustav remained the basic book type until Peter the Great included the alphabet among the many reforms he inspired. A man of great physical height and strength and immense energy, in the midst of making plans during the war with Sweden, he ordered new designs of type to supersede poluustav and to give Russian books something of the clear rational look of books from Italy, Holland and France and England. He wanted to open a window to the West and built Saint Petersburg, now Leningrad, on the marshes at the

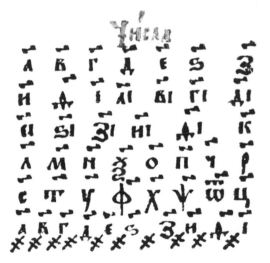

САНКТЪпітербурхЪ. **I**

ВѢДОМОСТЬ.

чрезЪ вѣну изЪ констянтінополя
ОтЪ 8 чісла декабря, 1714.

Сего дни по утру порпіа велѢла
съѢхатца всѢмЪ началнымЪ мінісшрамЪ, и офіцеромЪ иимеріи, на генералнои совѢтЪ, вЪ котоpомЪ опредѢлено воіну пpотівЪ pѢчи посполітои венеціискои объявіть.

<u>2</u> и по сему

Colophon of *Osmoglasnik*, the first book to be printed in Cyrillic type through the language was Ukrainian, not Russian. It was printed by Sh. Feol in Crakow, Poland, in 1491.

First page from the St. Petersburg newspaper *Vidomost*, 1714 set in Grazhdanski or Petrovski Shrift, the romanized Cyrillic type inaugurated by Peter the Great. First used in 1708. The round open feeling somewhat resembles Baskerville.

Page from an *azbuka* (a child's ABC Primer) printed by Burtzev in Moscow in 1634. This page is of Slavonic numerals (chisla) which were used before the introduction of Arabic numerals which replaced Slavonic by the 18th century in Russia. The mark above each letter indicates that it is to be read as a numeral. Beginning with A they read 1, 2, 3, 4 and so on. The bottom line, with a mark below the letter represents 1000's, and the line above signifies 100's.

Display type from Leman's type specimen book of 1901.

103

E. Bilibin, half-title to the magazine *Meer Isskustva* (*World of Art*) 1904.

V. Favorsky, from the *Book of Ruth*, 1924.

АБВГД

Part of an alphabet by F. Kustera, 1966.

Composition of the word Shrift by Ya. Dneprov, 1972.

ПИСЬМА

(1817 - 1840)

Title page by A. Krukov, 1966.

estuary of the Neva. He created a port with access to the Baltic and the rest of Europe. Peter personally supervised and approved the design of the new letter-form which is known as Grazhdanski Shrift or Civil Type also called Petrovski Shrift. He may even have made preliminary sketches, but it was one of his military draughtsmen who made the careful drawings which were sent to Amsterdam for punch-cutting and casting as type.

The type was first used for a book *Geometria*, a Russian version of a German book on Mathematics, and published in Moscow in 1708. It is a clear open rational letter not unlike Baskerville, though it is almost fifty years earlier. That there is a resemblance between Petrovski Shrift and Baskerville does not seem to me to be surprising—both are influenced, directly or indirectly by Dutch type designs.

About this time Arabic figures (numerals) came into use and Slavonic numbering gradually went out of favour.

Compared to the old Slavonic poluustav, Petrovski or Grazhdanski Shrift looks more like Latin—at least there is a family likeness.

Many of the letters are exactly the same in shape—A, B, E, K, M, N, O, P, C, T, Y, X—though some have a different

Villu Toots, Bookplate.

V. Y. Chibanik. Part of a catalogue cover. The words are Leonardo da Vinci. About 1972.

Villu Toots, Bookplate.

M. Rein. The word Ballet.

Villu Järmut. From an invitation card.

phonetic value. For example, B is pronounced like V, H like N, P like R, C like S. So the styles of letter fashionable in Europe were easily adapted to Cyrillic. Bodoni in Italy produced a very good Cyrillic type face. Other type-founders followed.

The styles of typographic layout current in Europe also appeared in Russia. From the late 18th century to the present day, most books in Russia could be matched with similar designs in England or France or Holland. The artistic movements like Art Nouveau were reflected in lettering. The parallel movement in Russia was called *Meer Isskustvo* or 'World of Art'.

But the way letters were used as images in themselves, the artists recognising the abstract beauty of letters in their own right during the revolutionary period from about 1917, Russian artists and designers anticipated the Bauhaus. Indeed, the germ of much of what came out of the Bauhaus and the subsequent movements in commercial and industrial design can be found in the work of El Lissitsky, Rodchenko, Annenkov, Gan and others working at that time. It is hard to realise how much in our visual environment that we take for granted goes back to that period of political intellectual and artistic ferment.

105

Vassily Lopata. Bookplate for the Museum of Folk Architecture of the Ukrainian Republic. Wood engraving.

А Б В Г Д Е
Ж З И К Л
М Н О П Р
С Т У Ф Х Ч
Ш Э Ю Я

Vadim Lazorsky, Alphabet.

А Б В Р
Д Е Ж З
И К М

S. M. Pozharsky. Part of an alphabet

А Б В Г Д Е Ж З
И К Л М Н О П Р
С Т У Ф Х Ц Ч Щ
Ъ Ы Ь Э Ю Я

E. I. Kogan. Alphabet

At the present time there are a number of distinguished letter designers working in the USSR. The best is acknowledged to be Villu Toots of Tallinn, Estonia. He is in the forefront of a vigorous school of letterers and to my mind one of the best calligraphers in the world.

S. M. Pozharsky died a few years ago after a lifetime of producing imaginative graphic art and fine lettering.

Vadim Lazorsky, who lives in Moscow, was awarded the Gutenburg prize in 1975 for his distinguished book design. He was commissioned by G. Mardersteig of the Officina Bodoni in Verona, to design a Cyrillic type, called Pushkin, to harmonise with Mardersteig's own 'Dante' type and used for a translation of Gogol with English on one half of the page and Russian on the other.

E. I. Kogan is a contemporary Moscow type designer and graphic artist. This is a satisfying design.

106

АБВГДЕЖ
ЗИЙКЛМ
ФХЦЧШЭ
НОПРСТУ
ЩЮЯЫЪ

S. Telingater. Alphabet 1958.

S. Telingater, alas, died in 1969 but left a large body of first rate graphic work from the time of the revolution until only a few years ago. His type on page 107 perhaps reminiscent of Zapf's 'Optima' is one of the best Cyrillic founts.

Vassily Lapata is a lively young illustrator from Kiev who takes lettering in his stride as does V. Chibanik another young Ukrainian artist. See page 105.

On page 105 will be seen the work of M. Rein, Villu Toots, Villa Järmut. Strictly, this work should come in the Latin section as Latin is the alphabet used for Estonian, but it seems logical to group them with other Soviet artists as they all work in Cyrillic if required.

АБВГДЕЖ
ЗИКЛМН
ОПРСТУХ
ФЦЧШЫ
ЩЬЪЭЮЯ

КУРСИВ

Nellie Lvova. Decorative cursive alphabet. About 1973.

Villu Toots is a virtuoso of the pen and brush. His penmanship is impeccable and his brush lettering has an astonishing freedom combined with discipline and legibility.

Villu Toots, brush lettering. About 1967.

Nellie Lvova designs mainly display lettering particularly as a guide to sign writers of cinema posters which are mainly hand-lettered. She teaches lettering at the Muxhina Art School in Leningrad with great verve and panache.

As long ago as 1931 Hugh J. Schonfield was aware that Hebrew 'could not perform the work which the Roman alphabet discharges with ease'. It lacked the repertoire of caps, small caps, lower-case and italic caps and lower-case. The emphasis of Hebrew was horizontal whereas the emphasis of the Roman alphabet was vertical. He set about designing Hebrew in the form of caps, lower-case, italic caps and lower-case based on Caslon, Nicholas Cochin, Cable, and Ultra Bodoni. Here is his design for 'Caslon' Hebrew Old Face Heavy. This, together with the italic caps and lower-case and a well reasoned account of how and why he produced these designs, were published in his book *The New Hebrew Typography* in 1932. He hoped his designs would give Hebrew Typography a new look.

Hebrew

Not many people speak and read Hebrew compared to the large numbers who use the Latin, Cyrillic and Arabic alphabets. Nevertheless, it seems important to me in this context as having a common ancestor in the North Semitic alphabet, and it is now the official language of the state of Israel.

But the use of Hebrew is not confined to Israel. Wherever there is a Synagogue, which means in most major countries in the world, Hebrew script will be seen in the Torah—sacred to the orthodox Jew.

For many generations Hebrew was a language for prayer only and most of the finest manuscripts were for religious purposes. The earliest printing in Hebrew was by Konte in Mantua, not later than 1480. He was proud of his books and said in a colophon he 'writes with many pens without the aid of miracles, for the spread of the Torah in Israel'. The first Hebrew Bible was by Soncino in 1488.

Very few variations of the alphabet have appeared since then, the most significant being in the 20th century. Hebrew, like Japanese (see page 124) has succumbed to the influence of European sans serif and on these pages you can see 'Oron' light, medium, bold and extra bold designed by Asher Oron of Jerusalem to whom I am indebted for permission to include his type and for much information about Hebrew.

Hebrew reads from right to left and has no caps and only one ascender compared with seven in Latin. There are five descenders as in Latin, but four of them are used at the ends of words only. There is a strong emphasis on horizontals in traditional Hebrew in contrast to the more vertical emphasis of Latin.

Today Hebrew must often be combined with other languages which use the Latin alphabet. Asher Oron has wisely designed his types to harmonise with Univers so that the two faces range at the x-height with the ascenders and descenders of both languages of equal length. The weights harmonise admirably.

התקוה

כָּל-עוֹד בַּלֵּבָב פְּנִימָה
נֶפֶשׁ יְהוּדִי הוֹמִיָּה,
וּלְפַאֲתֵי מִזְרָח קָדִימָה,
עַיִן לְצִיּוֹן צוֹפִיָּה.

עוֹד לֹא אָבְדָה תִקְוָתֵנוּ,
הַתִּקְוָה בַּת שְׁנוֹת אַלְפַּיִם,
לִהְיוֹת עַם חָפְשִׁי בְּאַרְצֵנוּ,
אֶרֶץ צִיּוֹן וִירוּשָׁלַיִם.

כָּל-עוֹד דְּמָעוֹת מֵעֵינֵינוּ
יִזְּלוּ כְגֶשֶׁם נְדָבוֹת,
וּרְבָבוֹת מִבְּנֵי עַמֵּנוּ
עוֹד הוֹלְכִים עַל קִבְרֵי אָבוֹת.

עוֹד לֹא אָבְדָה...

THE HATIKVAH
First Two Verses and Refrain

Verses and refrain from the *Hatikvah* set in Caslon Hebrew Old Face Heavy. Title in 18 pt; verses in 14 pt; refrain in italic 18 pt; repetition of refrain in 10 pt italic.

Jose Mendoza y Almeida. Vigorous Hebrew lettering combined with latin italic.

This type face, the first in Hebrew to be available in four weights, is also the first designed specially to align with the lower case of a Latin type face, for use together in bilingual printing of extended texts.

אות עברית זאת,הראשונה שעוצבה בארבעה משקלות,הותאמה במיוחד לשימוש עם סדרת יוניברס הלטינית. זאת הפעם הראשונה שאות עברית הותאמה לאותיות הקטנות באלף בית לטיני כך שיתאימו במיוחד, זו בצד זו, לטקסטים דו לשוניים ארוכים, בהם השימוש באותיות הגדולות (caps) בלבד יפגע מאוד בקריאות.

The above lines demonstrate the alignment of Oron Light, Medium, Bold and Extra Bold with Univers 45, 55, 65 and 75. They speak for themselves.

עומלכפן ecnolpן
עומלכפן ECNOLPן

As the traditional Hebrew letter form is squarish it seems natural to try to align the x-height of Hebrew with Latin caps as in the design by Zvi Narkis on the second line. This leaves the Hebrew ascenders and descenders protruding and can only be satisfactory with short sentences in caps. The first line, which is in Oron, is better with the alignment at the x-height and with ascenders and descenders of both alphabets of equal length.

אבגדהוזחטיכלמנסעפצקרשת םןףץ
abcdefghijklmnopqrstuvwxyz

Oron and Univers compared.

numbers 2359 מספרים
or numbers 2359 מספרים

Numerals at the height of Latin caps, compared with numerals ranging with the x-height.
The short numerals can be a useful alternative in the combination of both alphabets.

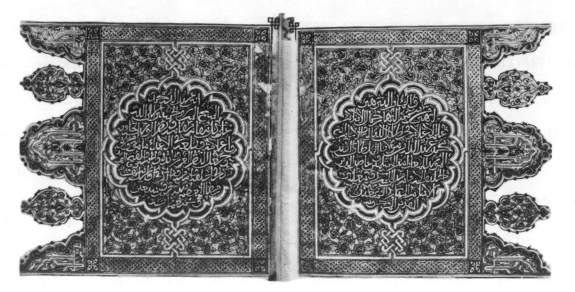

Colophon of a Koran stating that it was written for Abd Allah, second Sharifi Sultan of Morocco. A.D. 1568.

A fragment of the Koran in Kufic script.

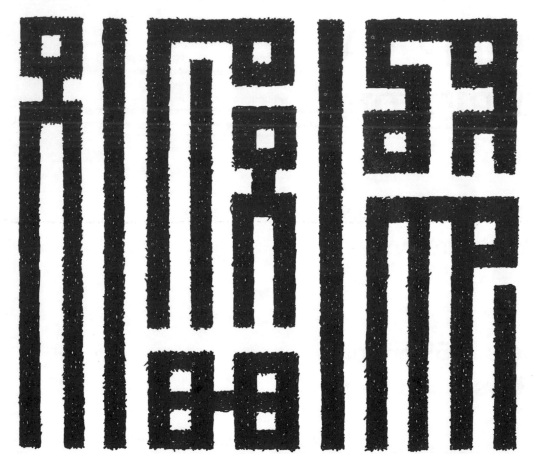

Arabic

Arabic is the official language of Morocco, Algeria, Tunis, Libya, the United Arab Republic, Sudan, Lebanon, Syria, Jordan, Iraq and the states of the Arabian Peninsula.
It is also used in Israel, in part of Iran, in parts of the Central Asian Republics of the Soviet Union and in areas on the southern border of the Sahara.

Arabic belongs to a family of languages usually called Semitic (see diagram on page 30). Many members of this family of languages are now dead, but Hebrew and some Ethiopian languages survive. The earliest example of a language which can be identified as Arabic is on a tombstone dated A.D. 328 found in the Syrian desert. In the centuries that followed, there is evidence of a body of poetry passed on by word of mouth and only written down in the 8th or 9th century.

But it was in the early years of the 7th century that the prophet Muhammad spoke of what had been revealed to him. His revelations were memorised by his followers and written down by amanuenses, and so the Koran (Qur'an) became the earliest surviving example of written Arabic apart from a few older inscriptions.

It appears that the language was similar to that of the 6th century poetry but was written down in a form which reflected the pronunciation of the western dialect of Mecca. About a century later, scholars of lower Iraq improved certain characteristics of Eastern dialects for use in recitation. They did this, not by altering the text, but by adding reading marks which resulted in some of the oddities of dots above letters which are present in Arabic script as it is used today.

In the 8th century, scholars feared that the change in the language due to its adaptation by large numbers of non-arabic peoples might lead to a loss of ability to understand the Koran just as the evolution of Romance languages led to the death of Latin for most Europeans. They set about formulating a grammar and lexicography with the intention of establishing 'correct' Arabic. The Arabic taught in schools in the Arab world today is virtually the same as that set down by the 8th century scholars.

Arabic writing is read from right to left. But we are here not so much concerned with the language as with the shapes of the letters and where Arabic differs from Latin and Cyrillic though it has the same distant ancestors. Perhaps the most striking difference is that there are distinct forms for many letters according to whether the letter comes at the beginning of a word—INITIAL; in the middle of a word—MEDIAL; at the end of a word—FINAL; or on its own—INDEPENDENT. This is clearly seen on page 117 where a fount of Hermann Zapf's Alharam type is shown. On pages 98–9 the independent form is shown with the exception of ba, ta, tha, jim, where the four forms are displayed. Letters can be divided into two groups:
those which can be joined on both sides;
those which can only be joined to a preceding letter.

The first group has the four forms already referred to and the second group has only the final and independent forms. Sometimes consonants may be placed on top of one another.

Though we take them for granted, the numerals we normally use are of Arabic origin. Just imagine what it would be like doing arithmetic with Roman figures! Arabic numerals are a reminder of the time in the 8–9th centuries when the Arabs were eminent mathematicians and they developed the numerals and the Hindu-Arabic system of counting in tens which made calculations so much easier. It was the Arabs who brought Algebra from the Hindus to the West and, indeed, gave us the word Algebra. The definite article in Arabic is al, and jabr refers to the reunion of separate quantities as when quantities on one side of an equation are brought together on the other side but with a changed sign.

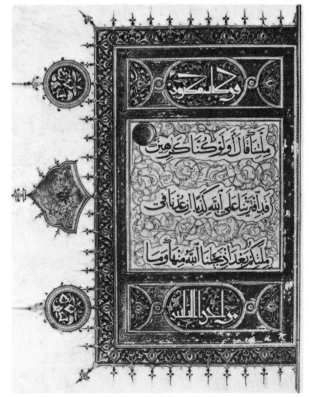

Koran. Egypt 14th century.

وَأَغْفَى صَمْتُهَا الْمَحْبُوبُ فَوْقَ اللَّيْلِ وَالْأَشْجَارِ
وَهَبَّتْ مِنْ رَوَائِحِهَا عُطُورُ الْأَمْنِ وَالْإِيثَارِ

Two lines from living poet Kamal Nas'at in 'nask' script.

وأغفى صمتها المحبوب فوق الليل والأشجار
وهبت من روائحها عطور الأمن والإيثار

The same in normal modern handwriting.

وأغفى صمتها المحبوب فوق الليل والأشجار
وهبت من روائحها عطور الأمن والإيثار

The same from the published poems in normal type.

في طبعة أولى سنة ألف وتسع مئة وتسع وخمسين
في المطبعة الكاثوليكية - بيروت - لبنان

A typeface of ta'liq inspiration.

شرح القصائد السبع الطوال الجاهليات

Title page in lettering inspired by Kufic script.

Above: two pages from a Koran.
Arabic 13th century.

Right: Calligraphy by Kamel Ba[...]
Lebanon. About 1970.

The word was first used in the title of a treatise by an Arab mathematician named Al Khowarazmi in the 9th century. The first word of a lengthy title was Al-jabr and Europeans referred to the treatise by this word which became latinised as Algebra.

Arabic letters are subject to some of the same treatments that we impose on the Latin alphabet. I mean being given a three dimensional effect or 'shadow'.

Kufic, which appears on page 114 is a formalised, static and vertically elongated form of considerable beauty. It is con-sidered by some to be the beginning of Arabic calligraphy as an art. Though the style is called Kufic it has no special connection with the city of Kufa in Southern Iraq. The basic style on which normal present day type faces are modelled is called nask which is derived from the medieval 'copy-book' style.

Architecture and calligraphy are considered the two great arts of Islam 'which have seldom been equalled and never surpassed, the one being centred on the Mosque and the other on the Koran'. But Islam almost excludes statuary and

ا ا ب ب ب ب ت تت تت ث ثث ث جج ج ج

ح ج ح ح خ خخ خ د دد ذ ذ ر رر ز ز س س

س س ش ش ش ش ش ص صص ص ض ضض ض

ط طط ط ظ ظظ ظ ع عع ع غ غغ غ ف فف ف

ق قق ق ك كك ك ل لل ل م مم م ن نن ن ه هه

ه ة و وو ي يي ي ـ ب ر ف ى كل الآ لج لم لى محمد لله

١٢٣٤٥٦٧٨٩٠

Alahram Arabic alphabet designed by Hermann Zapf.

التاجر مجده فى كيسه
العالم مجده فى كراريسه

Alahram Arabic Shadowed.

يا ايها الكتاب سر الى سيدنا الاعز
فسلم عليه بهذه الورقة
التى هى اول الكتاب وآخره
يعنى اوله فى المشرق وآخره فى المغرب

Alahram Arabic in action.

has never encouraged the painting of pictures or the representation of nature. Their genius then, went into writing and illumination and architecture—both abstract. The two frequently came together in a blissful union when quotations from the Koran were used to embellish the mosques in colourful ceramic.

There are many superb Arabic manuscripts in the British Museum and the Victoria and Albert Museum where the magnificent script may also be seen embellishing ceramic and metalware.

Arabic type faces by Hermann Zapf of Frankfurt, Germany in which his sense of pure, clear form is as evident as in his type Optima and all his work.

Above: The earliest known example of letter-press printing. It is a Buddhist charm printed from a wood block by order of the Empress Shōtoku of Japan. It is said that a million copies were printed between A.D. 762 and 769—no doubt by different calligraphers and different block-cutters and printers. A number of copies still exist. This one is in the British Museum.

Left: Modern Japanese calligraphy written specially for the author by Masahiko Kajuka a gifted calligrapher of Tokyo.

Chinese and Japanese

Chinese
Used in China, Taiwan, Hong Kong, Singapore, S.E. Asia and by minorities in the West Indies, large cities in America and elsewhere.

Japanese
Spoken mainly in Japan

Chinese and Japanese must be considered together because Japanese written characters are based on Chinese rather as Latin characters were based on Greek though the languages are different. Chinese culture, and with it the form of writing, was introduced into Japan in the Asuka (A.D. 552–646) and Nara (A.D. 646–794) periods. Since then Japanese calligraphy has developed characteristic styles, but always under the influence of Chinese. Nevertheless Japanese is 'unusual among the worlds languages' and quite different from Chinese.

The Chinese regard Calligraphy as one of the highest forms of art. According to Chiang Yee 'it is in a sense the chief and most fundamental element in every branch of it. Chinese characters not only serve the purpose of conveying thought, but also in a peculiar visual way, the beauty of the thought'. Chinese children were taught to respect writing and not to misuse paper which had writing upon it, so that even the destruction of paper with writing upon it was done in a special little pagoda called 'The Pagoda of Compassionating the Letters'. I do not know whether the custom survives in the new China, but the instinct for conservation and tradition is so strong in the Chinese character that it probably goes on, if not so widespread as in the past.

There is little doubt that most forms of writing began as simplified pictures of things (pictograms). It is not easy to see the pictographic origins in any of our Latin letters, but in many Chinese characters we can still see dimly the picture of the thing in the pattern of brush strokes of a modern letter. This is very evident in the character of 'fish' on page 121. The simplification of the form has been brought about partly by the tool with which it was made (usually a brush) and the need to reduce the image to as few strokes as possible and which could be made by any reasonably intelligent person.

The normal writing instrument for writing in China was the brush whereas in Europe it was the edged pen. It will be noticed that this instrument for writing is also the implement for painting. Writing easily grows into painting and so the written characters harmonise so well with painted forms. It was customary for a poem or other form of words to be an integral part of a picture. Chinese calligraphy has some of the free quality of painting, and painting has some of the pre-conceived quality of calligraphy.

The characteristic shapes of Chinese calligraphy are based not only on the brush as distinct from the pen, but from the way the brush is held. The brush is held vertically (see page 122) so that by gradually exerting pressure a similar sort of swelling stroke can be made in whatever direction the hand moves. This is in contrast to the European use of the edged pen where the direction of movement conditions the thickness of the stroke, not the pressure. When writing Chinese characters the hand not only changes direction many times but rises and falls in an almost dance-like rhythm. I like to think of Chinese and Japanese Calligraphy as the Choreography of the Brush.

Though we are here concerned primarily with the shapes of Chinese characters and the inspiration which may be derived from their study and the relation of these letters to other forms of writing, it is desirable to learn a little about the language. Incidentally, most teachers of Chinese recommend the writing of the characters as one of the best ways of memorising them and learning their meaning.

Chinese is not a phonetic form of writing. Every character represents a complete idea not a sound of speech as do the letters of an alphabet. The letters of an alphabet are meaningless until they are arranged into groups which represent the sound of the spoken word.

On the face of it, it may appear that a separate character is needed for every idea resulting in an enormous number of characters being necessary for intelligent communication. One of the most famous dictionaries, that of K'ang-Hsi, contains over 40,000 different characters! But just as we enjoy adequate conversation and communication about important matters with considerably less than the prodigious number of words in the Oxford Dictionary so, in China, it is possible to carry on everyday conversation with a mere 1,200 characters and 2,000 would enable the reader to understand modern prose literature. Nevertheless this seems a formidable obstacle to learning the language particularly when one must also memorise the romanised phonetic form called Pin Yin as well as the meaning, the grammar, and the order in which strokes have to be made to form a character correctly. It is not surprising that many attempts have been made to reform the language, indeed, one authority states that 'the history of attempts at language reform is the history of modern China in miniature'.

The official language of the Peoples Republic of China is Mandarin or Modern Standard Chinese which is also used in Taiwan (Formosa). In Hong Kong, Singapore and elsewhere

Mandarin is a minority language; the variety of Chinese is likely to be Cantonese. In America, the Chinese dialect is usually Hakka.

As the basic characters are themselves non-phonetic readers may pronounce the words in a wide variety of ways. This has advantages and disadvantages. The fact that peoples who speak differently from one another can read a common script, is considered by some to be an advantage. It has been argued from this that Chinese could be a 'universal script par excellence' and the philosopher Leibnitz has been quoted in its support. The Swedish Sinologist Karlgren called Chinese 'Esperanto for the eyes'. I am unconvinced by this argument. Chinese is more likely to be westernised in some way or other. But I cannot imagine the Chinese and Japanese abandoning such a beautiful and ancient script.

However, some concessions to Western ways, influenced by technology, have already occurred. Traditionally Chinese is written in vertical columns, one character under another, starting from the right-hand side of the page. As each character is a complete idea it does not matter whether the characters are placed under one another or arranged side by side. They could be read either from left to right or right to left. For some time now in China type has been set in horizontal lines and Peking has decreed that henceforth printing and writing shall be in horizontal lines and read from left to right. But older people still write downwards in vertical columns starting on the right.

Chinese printing outside China may be inconsistent. On the same page of a newspaper, headlines may be seen running horizontally from left to right and from right to left, adjoining columns of characters set vertically in the traditional manner.

But we are concerned to understand something of the visual nature of Chinese characters and how the traditional order of writing from the top down is integrated with the order of writing the strokes within each character which is from left to right. I cannot do better than quote Kozuka, masahiko a brilliant young Japanese calligrapher and designer.

Because we are used to writing from left to right we are inclined to believe that this is natural in spite of the fact that such ancient scripts as Hebrew and Arabic are written from right to left. Of Chinese Kozuka says 'as long as there is gravity on earth, the form psychology in the up-down direction will not change. In connection with the left-right direction, although we have the custom of writing up and down, I feel that the consciousness is the same as long as we have been raised to write with the right hand.' He goes on to say that Chinese characters compared to the Latin alphabet, have an extra dimension within one word—the up-down direction on top of the left-right direction. He says that even in the Mincho style 'the weight is on the right, and the directional course to the right has to be taken into consideration'.

I believe there is a parallel in European writing where most strokes are made with the pen pulling down towards the body yet at the same time each letter must relate to its neighbours and assist the movement of the eye towards the right.

PĪNYĪN

Pīnyīn, or to give it its full name Hanyu Pīnyīn, is a system of representing the sounds of Chinese speech by means of the Latin alphabet. It has been the official form of romanised Chinese since 1958 but it has developed over a long period.

It seems to have evolved from Latinxua, a system devised and used in the Soviet far east way back in 1931. In the Soviet parts of Mongolia the language is transliterated into Cyrillic whereas in Chinese Mongolia it is written in Chinese characters. Though Pinyin employs the Latin alphabet, the sounds represented by Pinyin must still be learned as they do not always coincide with normal English pronunciation.

When words are represented each syllable has a diacritical mark over it to indicate the tone in which it is to be pronounced. In Mandarin there are four tones in which a given word may be spoken. The tone in which it is spoken alters the meaning. The tones may be referred to in various ways. For example: 1st tone—high; 2nd tone—high rising; 3rd tone—falling and rising; 4th tone—falling. The standard text book planned and printed in China for teaching Chinese to English speaking people, refers to five pitches on the diagram though there are but four tones which are indicated by diacritical marks.

HĀNYǓ PĪNYĪN

Approximate pronunciation

A = ah, but not as short as hat
B = as English b, but with more breath
C = ts
D = da with slightly more breath
E = a
F = fa
G = as in get
H = between Scottish ch and h
I = ee yee
J = gee, usually before u or i
K = k but slightly more aspirated
L = l
M = m
N = n
O = or
P = p but slightly more aspirated
Q = unvoiced j
R = r but never trilled
S = s
T = t, slightly aspirated
U = oo
W = w
X = shee (hs)
Y = only at beginning of a syllable
Z = dz
ZH = like English J
CHI = chir
ZHI = jur
SHI = sher
CI = ts
ZI = dzer
SI = ther

The diacritical marks
1st tone
2nd tone
3rd tone
4th tone

5 high pitch
4 mid high pitch
3 middle pitch
2 mid low pitch
1 low pitch

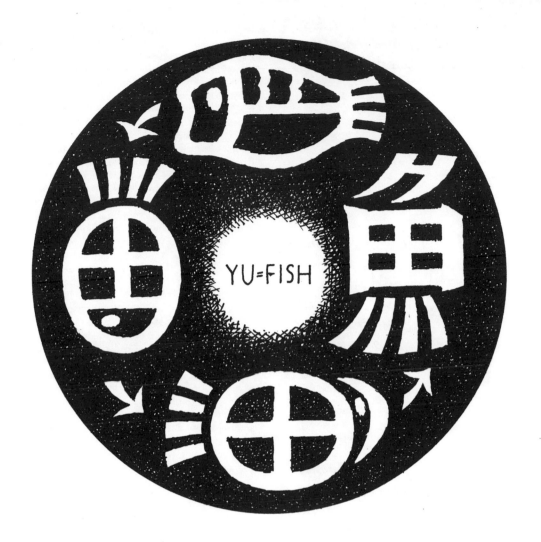

YU=FISH

人	大	天	女	子	好
A man. Person. Human being	Big. great. (a man with outstretched arms)	Heaven, sky (something above man)	Woman feminine	Child	Good (a woman and child)

We are here talking of how the calligrapher, professional or amateur, works. For everyday use the Chinese and Japanese write with pencils, ball-point pens and nylon tipped pens just like we do. But the brush is the instrument for fine writing.

The sketches explain better than many words how the brush is held by the Chinese and Japanese for formal writing and painting. They usually stand when writing anything large. If they sit, they prefer the height of the chair to be so that the

121

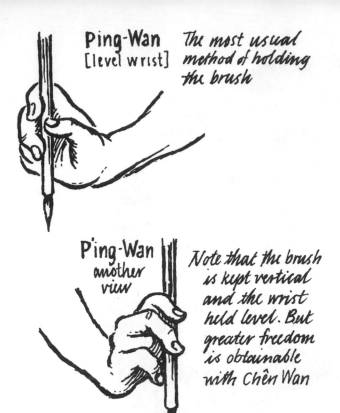

Ping-Wan [level wrist] *The most usual method of holding the brush*

Ping-Wan another view *Note that the brush is kept vertical and the wrist held level. But greater freedom is obtainable with Chên Wan*

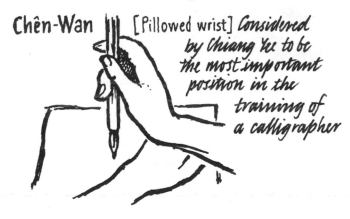

Chên-Wan [Pillowed wrist] *Considered by Chiang Yee to be the most important position in the training of a calligrapher*

Ink Slab

Stick of ink

level of the waist is just below the level of the table. This gives greater freedom of movement. The table is flat, in contrast to the European scribe's sloping writing desk. The paper is always laid flat.

The paper is more porous than that usually used in the West. In paper-makers jargon it is 'water leaf' or unsized. For practice cheap paper is used. In the West, newsprint is an adequate substitute while learning to handle the brush. A second sheet of paper is put under the one being written on.

Chinese ink is different from that usually used in the West. It is made from the soot of burnt pine-wood or from oil-smoke, lamp-black mixed with gum and left to solidify in sticks. These sticks are usually about 102 x 26 x 10 mm and are often decorated with patterns and letters in gold that make the sticks objects of beauty in themselves. I have one in my possession which is so handsome I am loath to destroy it by use.

The stick of ink is rubbed on an ink stone (see illustration) made of a kind of slate and with a recessed surface that slopes down to a deeper region or ink well. These ink stones too are often delightfully decorated. The stick of ink is rubbed on the stone with water until the required quantity or density is achieved. A strong solution may be diluted with more water, but it is important that enough ink be ground at one time to complete any one piece of writing. It is always best when freshly ground.

Chinese brushes may be made of the hair of the deer, fox, wolf, rabbit or even mouse. The hairs are bunched to make a fine symmetrical point, and cunningly inserted into a hollow cane or thin bamboo. The hairs are usually protected by another piece of hollow cane fitting over the bristles like the top of a fountain pen. Again the Chinese decorative sense is apparent in the ornamentation of the cane with golden characters.

There are many recommended positions for holding the wrist, hand and arm while writing though only two are illustrated here. Positions with the wrist or arm touching the table are suitable for writing small characters. Larger forms require great freedom of movement. Chiang Yee says 'if no part of the arm touches the table, the strength of the whole body can pass through the shoulder, arm, elbow, wrist and fingers to the brush-point, and the strokes of the brush will be correspondingly vivid'. There is a lesson here to be learned by letterers in the West. No preliminary sketching is done on the paper so that the letters may pour out of the brush unimpeded by guide lines.

On the other hand, much preliminary thought and practice is done. The conscientious Chinese scribe will meditate while he grinds his ink and he will devote time to visualising the characters and the composition, before embarking on the adventure of writing. Good writing, like painting, begins in the mind; the hand is the instrument of the mind.

Each Chinese character is always written as though in an imaginary square. The square may be divided (in the mind) into either two or four parts according to the complexity of the characters. But some characters are so intricate that a square divided into nine parts makes a better grid. Even if the character is not very complicated the nine part grid can give a proportion of 2:1 both vertically and horizontally which is often more satisfactory than 1:1.

Only eight strokes are illustrated here. The first seven are recommended in beginners text books on Chinese as being the most elementary and as being the most frequently used. But the number of strokes, each with a name, is considerable.

丶 diǎn	一 héng	丨 shù	ノ piě
㇏ nà	㇀ tí	亅 shù·gōu	フ pau·kou

character meaning		stroke order	pīn-yīn	Rules of writing
十	ten	一 十	shí	heng precedes shù
大	big great	ナ 大	dà	piě precedes nà
多	many much	夕 多	duō	from top to bottom
你	you	亻 尔	nǐ	from left to right
月	month	刀 月	yuè	from outside to inside
国	country	冂 囯 国	guō	inside precedes sealing stroke
小	small	亅 小 小	xiǎo	middle precedes sides

Chiang Yee gives over fifty; the Lady Wei distinguished seventy-two.

The terms used by the Chinese to describe the quality of strokes seem to me to be applicable to good calligraphy in any script in any part of the world. They are *bone, flesh, muscle* and *blood*. Lady Wei said 'in the writing of those who are skilful in giving strength to their strokes, the characters are "bony"; in the writing of those who are not thus skilful, the characters are "fleshy". Writing that has a great deal of bone and very little meat is called "sinewy", and writing that is full of flesh and has weak bones is called "piggy". Powerful and sinewy writing is divine; writing that has neither power nor sinews is like an invalid.' (Translated by Lin Yü-Tang in *My Country and my People*.)

Above is an adaptation from a recent text-book published and printed in China, intended for the use of English speaking people who wish to learn Chinese as a foreign language. It shows the first few strokes which the beginner is advised to learn, with simple rules of stroke order and the pin yin pronunciation.

123

アイウエオカキク
ケコサシスセソタ
チツテトナニヌネ
ノハヒフヘホマミ
ムメモヤユヨラリ
ルレロワヲンガグ
ゲザジズダヅバビ
パピプペー・アイウエ

ABCDEFGHI
JKLMNOPQR
STUVWXYZ&
1234567890:,
abcdefghijkl-
mnopqrstuvw
xyz

Related Kana and Latin letters designed by
Yasaburo Kuwayama for the Nissan Company.

124

●かなのエレメントとその呼び名

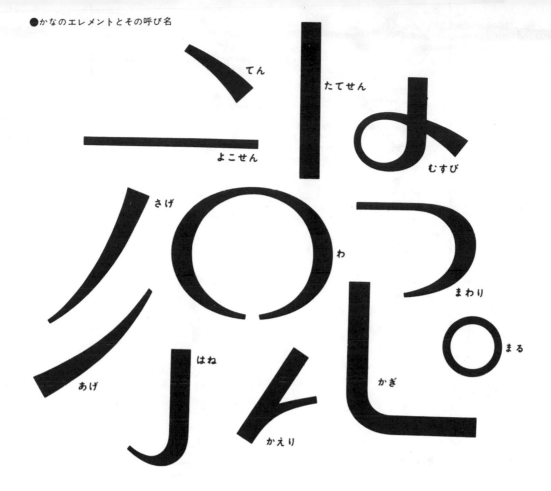

てん
たてせん
よこせん
むすび
さげ
わ
まわり
まる
あげ
はね
かぎ
かえり

●エレメントによる文字構成

ー+｜=エユコヨロキ　　ー+｜+ノ+し+、=え　　ー+○=ひ　　　　｜+○+ノ+ぁ=ぬ
ー+｜+ぁ=はほ　　　　ー+｜+๐+ノ=す　　　ー+し=も　　　　｜+ノ+J=ん
ー+｜+ぁ+ノ=み　　　ー+｜+○+、=お　　　ー+ノ+J=カ　　　ノ+○=の
ー+｜+ぁ+つ=るね　　ー+｜+J+、=か　　　｜+ノ=レ　　　　ノ+、=メソツハく
ー+｜+ノ+こ=をたに　ー+し=モ　　　　　　｜+○+ノ=ゆめ　　つ+、=う

漢字のエレメント

| 電 | 穴 | 入 | 尸 | 月 | 言 | 木 | ネ | シ | 女 | 糸 |
| 儿 | 辶 | 欠 | 阝 | 書 | 武 | 体 | 線 | 更 | 討 | 要 | 展 |

A printed page of Japanese usually consists of a mixture of (1) Kanji, Chinese derived characters; (2) Hiragana, a cursive sound syllabary script which is comprised of some basic elements taken from the Kanji; and (3) Katakano, an angular type face of sound syllabaries. The Typos Group of designers in Tokyo (kathuichi ITO, yasaburo KUWAYAMA, katsumi NAGAI A, takao HAYASHI) worked for many years to produce a new Kana (Katakana) typeface to harmonise both with the traditional forms and European sans serifs that now occur on the same pages, particularly of magazines and newspapers.

Above are the twelve basic strokes of which Kana is composed. Immediately below the large basic strokes is a sequence showing how one stroke is added to another to form the most complex of characters. The twelve elements are known as 1, Dot; 2, vertical stroke; 3, horizontal stroke; 4, closing stroke; 5, round stroke; 6, down stroke; 7, circular stroke; 8, turn stroke; 9, up stroke; 10, down kick stroke; 11, return stroke; 12, locking stroke. Any Kana character can be made with combinations from these twelve strokes. In writing, the order in which the strokes are made is important.

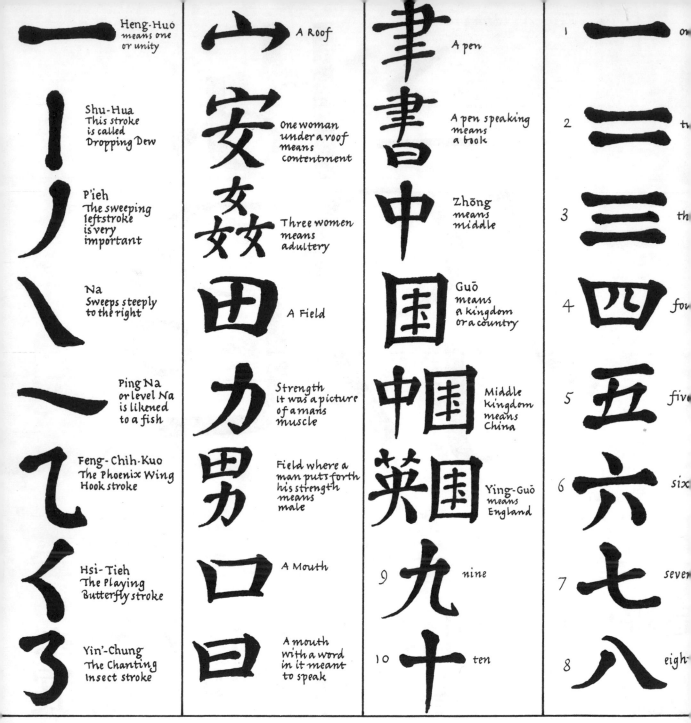

一	Heng-Huo means one or unity	宀	A Roof	聿	A pen	一	1	on
丶	Shu-Hua This stroke is called Dropping Dew	安	One woman under a roof means contentment	書	A pen speaking means a book	二	2	tw
丿	P'ieh The sweeping leftstroke is very important	姦	Three women means adultery	中	Zhōng means middle	三	3	th
乀	Na Sweeps steeply to the right	田	A Field	国	Guó means a kingdom or a country	四	4	fou
乀	Ping Na or level Na is likened to a fish	力	Strength It was a picture of a man's muscle	中国	Middle Kingdom means China	五	5	five
乛	Feng-Chih-Kuo The Phoenix Wing Hook stroke	男	Field where a man puts forth his strength means male	英国	Ying-Guó means England	六	6	six
乁	Hsi-Tieh The Playing Butterfly stroke	口	A Mouth	九	9 nine	七	7	seven
了	Yin'-Chung The Chanting Insect stroke	曰	A mouth with a word in it meant to speak	十	10 ten	八	8	eigh

Above: some of the basic strokes and their picturesque Chinese names. Also a few of the simpler characters in which the original pictogram is still discernible. Different but related meanings may be obtained by adding one character to another—as one woman under a roof means contentment; a woman with a child means good.

Right: A contemporary calligrapher at work in Japan, with some of his vigorous colourful work.

大
受

大
輪
島

高
島

魁
傑

貴
員
員

若
島
晃

Book List

About alphabets, Herman Zapf, Massachusetts, 1970.
Pen and Graver, Hermann Zapf, New York, 1952.
An Illustrated History of Writing and Lettering, Jan Tschichold, London, 1946.
Writing, David Diringer, London, 1962.
A Book of Scripts, Alfred Fairbank, London, 1949.
Alphabets, Edward Strange, London, 1907.
Lettering, H. Degering, London, 1929.
Writing and Illuminating and Lettering, Edward Johnston, London, 1906 and many later editions.
Lettering, Graily Hewitt, 1930.
Alphabets Old and New, Lewis F. Day, London, 1910.
Lettering as Drawing, Nicolette Gray, London, 1970.
The Alphabet and Elements of Lettering, Frederick W. Goudy, New York, 1963.
The History and Techniques of Lettering, Alexander Nesbitt, New York, 1957.
Of the Just Shaping of Letters, Albrecht Dürer, New York, 1965.
The Story of the Alphabet, John R. Biggs, Oxford, 1968.
The Craft of the Pen, John R. Biggs, London, 1961.
The Craft of Script, John R. Biggs, London, 1964.
The Craft of Lettering, John R. Biggs, London, 1961.
Approach to Type, John R. Biggs, London, 1961.
The Use of Type, John R. Biggs, London, 1954.
Basic Typography, John R. Biggs, London, 1968.
Encyclopaedia of Type Faces, Berry, Johnson and Jaspert, London, 1958.
The Roman Alphabet, Allen W. Seaby, London, 1925.
Lettering of Today, C. G. Holme, London, 1937.
Lettering of Today, John Brinkley, London, 1965.
Letters Redrawn from the Trajan Inscription, Edward M. Catich Davenport, Iowa, 1961.
Roman Lettering, L. C. Evetts, London, 1938.
An Alphabet Source Book, Oscar Ogg, New York, 1947.
Lettering, John Tarr, London, 1951.
Letter and Image, Massin, London, 1970.
The Written Word, Etiemble, London, 1962.
Civic and Memorial Lettering, Percy Smith, London, 1946.
Lettering in Book Art, Imre and Hedwig Reiner, St. Gall, 1948.
Alphabets and Images, Maggie Gordon, London, 1974.
Comic Alphabets, Eric Partridge, London, 1961.
Decorative Initial Letters, A. F. Johnson, London, 1931.
From Cave Painting to Comic Strip, Lancelot Hogben, London.
The letter as a Work of Art, Gerard Knuttel, Amsterdam, 1951.
Graphic Design: Visual Comparisons, Fletcher, Forbes, and Gill, London, 1963.
Signs in Action, James Sutton, London, 1965.
The Visible Word, Herbert Spencer, London, 1968.
From Script to Print, H. J. Chaytor, London, 1966.
Languages of the World, R. A. Downie, Redhill, 1963.
The Penguin Atlas of Ancient History, Colin McEvedy, Harmondsworth, 1975.
Die Kunst der Schrift, Unesco, 1964.
Greek and Latin Palaography, Edward Maunde Thompson, London, 1893.
The Local Scripts of Archaic Greece 1743, Lilian H. Jeffery, Oxford, 1961.
The Universal Penman (facsimile), George Bickham, New York.
Dossier A–Z 73, A. Typ. I, Brussels, 1973.

Karlgeorg Hoefer, Hans Halbey, Offenbach am Main, 1963.
Hans Schmidt, Hans Halbey, Offenbach am Main, 1961.
Three Classics of Italian Calligraphy (facsimile), Oscar Ogg, New York, 1953.
Early New England Gravestone Rubbings, E. V. Gillon, New York, 1966.
English Church Memorials, Frederick Burgess, London, 1963.
An Essay on Typography, Eric Gill, London, 1936.
Typography: basic principles, John Lewis, London, 1963.
Experimenta Typographica II, Sandberg, Cologne, 1956.
Typographie, Emil Ruder, Switzerland, 1967.
Typography: how to make it most legible, Rolf F. Rehe, Indianapolis, 1974.
Typography, Aaron Burns, New York, 1969.
Printing Types: their history, forms and use, D. B. Updike, London, 1937.
The Invention of Printing in China, T. F. Carter, New York, 1955.
Type Designs of the Past and Present, Stanley Morison, London, 1926.
Type Designs, their history and development, A. F. Johnson, London, 1934.
Typographical Printing Surfaces, Legros & Grant, London, 1916.
Lettering, B. Voronetsky, Leningrad, 1975.
Artistic Heritage of Ivan Fyodorov, Yakim Zapasko, Lvov, 1974.
Contemporary Lettering, Villu Toots, Moscow, 1966.
Estonian Lettering Art 1940–1970, Villu Toots, Tallinn, 1973.
Russian Typographic Letter-forms, A. Shitzgal, Moscow, 1974.
Russian Civil Type (Grazhdansky Shrift), A. Shitzgal, Moscow.
Engravings of Francisca Skorina, L. Barazny, Minsk, 1972.
A.B.C.'s from Fyodorov to Modern Times, Moscow, 1974.
Lettering, Vassily Ionchev, Sophia, 1971.
Early Russian Manuscript Books, A. H. Sverin, Moscow, 1964.
Early Russian Book Engravings, A. A. Sidorov, Moscow, 1951.
Russian Graphics at Beginning of 20th century, A. A. Sidorov, Moscow, 1969.
Lubok—Popular Prints of 17th & 18th Centuries, Yuri Ovsyannikov, Moscow, 1968.
Book Art (Isskustva Knigi), 1965, 1966, 1967. Moscow, 1968.
Books in the U.S.S.R., A. Puzikov, Moscow, 1975.
Lettering, O. V. Snarsky, Kiev, 1975.
Slavonic Manuscripts XI–XIV century, Academy of Science Library, Kiev, 1969.
Chinese Calligraphy, Chiang Yee, Harvard, 1973.
Chinese Written Characters, Rose Quong, New York, 1968.
The Art of Japanese Calligraphy, Yujiro Nakata, New York and Tokyo, 1973.
Graphic Design No. 58, Yujiro Nakata, Tokyo, 1975.
Japan Typography Annual, Yujiro Nakata, Tokyo, 1974.
Typo 1 and Typo 2, Yujiro Nakata, Tokyo, 1968.
Teach Yourself Chinese, H. R. Williamson, London, 1974.
Evolution of Chinese Writing, W. M. Hawley, Hollywood, 1968.
A Handbook of Asian Scripts, British Museum, London, 1966.
The Arabic Language Today, A. F. L. Beeston, London, 1970.
Teach Yourself Arabic, A. S. Tritton, London, 1962.
Writing Arabic, T. F. Mitchell, Oxford, 1958.
Hebrew Alphabets: 400 B.C. to our days, Reuben Leaf, New York, 1950.
The New Hebrew Typography, Hugh J. Schonfield, London.